THE NORWICH SCHOOL

CROME, COTMAN AND THEIR FOLLOWERS

THE NORWICH SCHOOL

CROME, COTMAN AND THEIR FOLLOWERS

HUON MALLALIEU

ACADEMY EDITIONS · LONDON / ST. MARTIN'S PRESS · NEW YORK

My thanks are due to the Norwich Castle Museum and in
particular Miss Norma Watt, for their help in supplying
photographs and information and to the private collectors
who allowed their paintings to be reproduced in this book. I
would also like to express my gratitude to Miss Caroline Smyth
who typed the manuscript.

First published in Great Britain in 1974 by
Academy Editions 7 Holland Street London W8

Cloth SBN 85670 134 3 Paper SBN 85670 184 X

First published in the U.S.A. in 1974 by St. Martin's Press Inc.
175 Fifth Avenue New York N.Y.10010

Library of Congress Catalog Card Number 74-19916
Printed and bound in Great Britain at
Burgess & Son (Abingdon) Ltd Abingdon Oxfordshire

Contents

IN Italy, just as every town of any size seems able to boast of a cathedral and a bishop if not a cardinal, it sometimes seems to the jaundiced eye of the traveller that each village is credited with its own school of painting lovingly chronicled and analysed by generations of art historians. In England, on the other hand, regional groups of artists and their differences of style have been largely passed over. Bristol, the North, and the West Country, may in time achieve a full measure of critical recognition, but at present only Norwich is generally allowed to have produced a School.

Why Norwich rather than York, or Liverpool, or Bristol or any one of the other prosperous areas of the country, each of them rich in potential or actual art patrons and well able to produce good or even great artists of their own? One basic reason can be found in Noel Coward's dismissive statement of the obvious, 'Very flat, Norfolk.'

Here on the most exposed corner of the great East Anglian plane, from which the sea seems only to have made a temporary and unwilling retreat, it is impossible to avoid a consciousness of the power of the elements. The vastness of sky, the circular completeness of horizon and the spaciousness of the endless heathland are strangely disturbing to the stranger used to the womb-like security of wood and valley afforded by other more secure counties. Human existence is a thin skin stretched between the immensity of the earth and the dominant sky. It was natural that when, at the end of the eighteenth century, Norfolk began to produce its own artists, they should turn for inspiration to works produced in similar conditions, to the landscapes of the Dutch Masters rather than to the classical serenity of Claude Lorrain's Italy.

Throughout the century British art had existed largely in the shadow of the great Frenchmen and Italians. English scenery was clothed not in its native greens, but in the burnt browns of Italy, and lit by a sun unknown in northern countries. A landscape was judged on its fidelity to the borrowed formulae of the masters, and among a host of academic imitators England had even produced in Richard Wilson an original genius worthy to take his place as an equal with Lorrain and Poussin. But lesser men were limited by the prescribed rules; as Constable said, 'English country gentlemen in their wigs, jockey caps, and top boots, with packs of hounds, careering in Italian landscapes resembling those of Gaspard Poussin in everything excepting truth and force.'

Thus, by the 1790s, the English were ready to turn from such sterile practices and seek new prophets, and the dispersal of the aristocratic collections of Dutch paintings in the early years of the French Revolution, especially of the great Orleans collection in 1792, provided the necessary impetus. Soon no fashionable amateur in England could sully his lips with the names of his old heroes, the Carracci, Rosa, Guercino, the Poussins or Lorrain: now all his talk was of Hobbema, Ruysdael, van de Velde, Rembrandt, and, above all, Aelbert Cuyp.

In Norwich, geographical, commercial and racial ties ensured an immediate sympathy with the new fashion. First English patriotism and then local patriotism in matters of art, as in so much else, were encouraged by the isolation from the Continent which began with the French Revolution. The town's relative remoteness from London meant that although the more important happenings in the capital were known, Norwich artists were free to interpret them in their own way. The town too was governed by a bourgeois merchant oligarchy whose wealth was already well established and whose taste was uninfluenced either by the cosmopolitanism of the aristocracy, or by the flashiness of the new

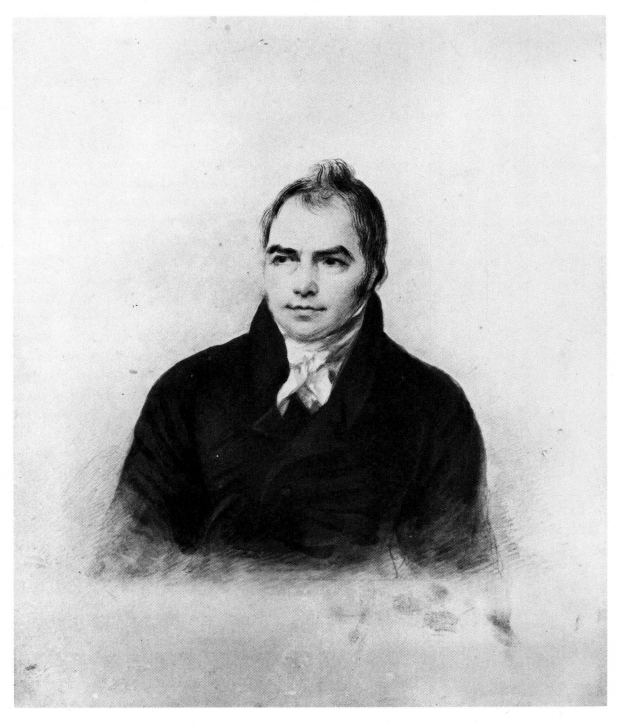

John Crome D. B. Murphy 17.8 × 14.7 cm watercolour (National Portrait Gallery)

rich in the rapidly growing northern cities. These men, Harvey of Catton, the Gurneys, Dawson Turner and others like them wanted pictures that they understood and representations of scenes they knew and loved, and were in instinctive sympathy with the aim formulated by the Norwich artists, on the formation of their society, to take nature as their only guide. The setting was an ideal one for John Crome, Robert Ladbrooke, John Sell Cotman, their children and followers, and perhaps the most useful way to trace the development of the school is through the lives of Crome and Cotman, the two suns around which all the others orbited.

John Crome was born on 22 December 1768 in the King and Miller Public House, Tombland, Norwich, the son of the landlord John Crome and his wife Elizabeth. As his name shows, he was of pure Norfolk descent, 'crome' being an East Anglian word meaning a crook or hooded stick. The public house was a poor one, and Crome senior had given it up by 1770, presumably in favour of his secondary living as a journeyman weaver. It is probable that he was able to afford little or no formal education for his son, and at the age of twelve young John was working as an errand boy at an apothecary's shop owned by Dr. Edward Rigby. Rigby was a cultured man as well as the owner of an estate at Framingham, six miles from Norwich, on which he experimented in agricultural improvements. His daughter later became an art historian and the wife of Sir Charles Eastlake, P.R.A.

No doubt it was Rigby who first awakened Crome's artistic instincts, but the boy only remained in his employment for two years. By the end of that time, the doctor could take no more of his practical jokes, which included switching the labels on medicine bottles to see whether the patients would notice, and Crome was apprenticed to Francis Whistler or Whisler, a coach, house and sign painter. In the following seven years he learned much which was to be of use in the practical aspects of his future career. The paints and varnishes which he ground and mixed for his master's coaches or inn signs had to be tough, lasting and weatherproof. That his own pictures have survived so well, undamaged and free from cracks, is probably due to this early training. The painting of signs, too, taught him the value of simplicity in design and construction which again is a marked feature of his mature work.

During his apprenticeship, Crome became friendly with Robert Ladbrooke who was articled to an engraver and printer to learn the 'art and mystery of printing'. The two youths rented a garret studio which they kept until 1792, and where they tried to obtain a wider experience than was available in the limited fields of their masters' businesses. In theory Ladbrooke specialised in portraiture and Crome in landscape, but in fact since sitters and commissions were few, they took whatever work was offered, even making cake designs for confectioners. A few of their sketches were exhibited and some even sold by a firm of Norwich printsellers, but, with little choice in the matter, the two young men went through the period of struggling poverty traditionally prescribed for the great artist.

It was, however, at about this time that Crome acquired his first important patron, probably through the good offices of Dr. Rigby, who, despite their earlier contretemps, remained friendly towards the aspirant painter. Thomas Harvey of Catton was a member of one of the most prominent mercantile families, and a keen collector and amateur artist. His connections with Holland were not only commercial, but personal also, for he had married the daughter of one of the chief Rotterdam merchants, and his collection strongly reflected these ties. He allowed Crome free run of his studio and

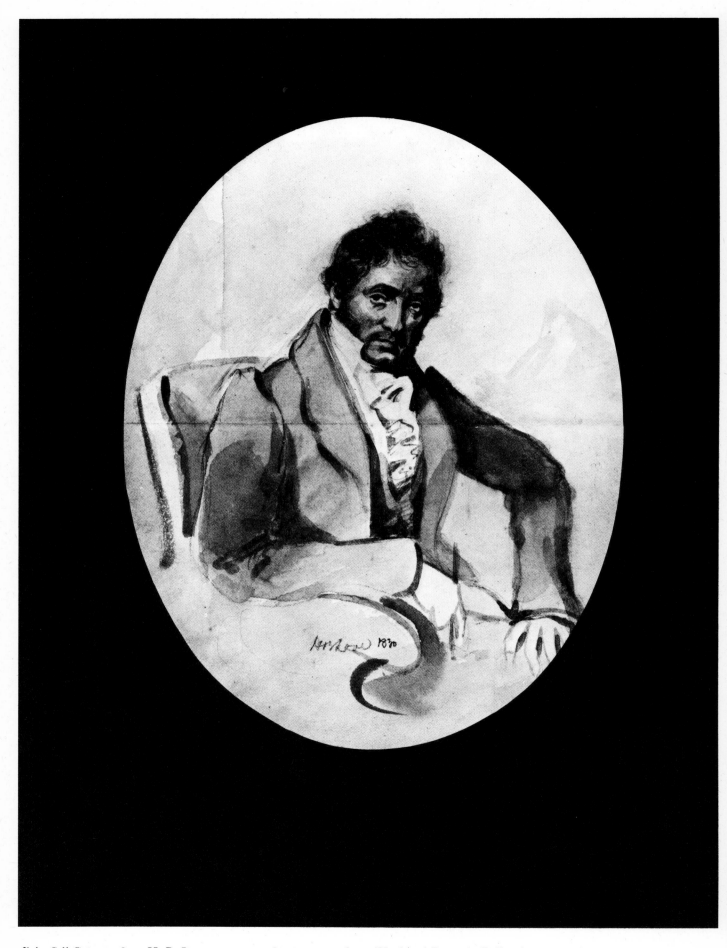

John Sell Cotman 1830 H. B. Love 25.7 × 19.6 cm watercolour (National Portrait Gallery)

gallery, and it was there that Crome saw a landscape by Hobbema which he copied and from which he tried to form his own style. The artist's last words were 'Oh Hobbema! My dear Hobbema, how I have loved you', but although he owed much to the Dutch master, the dependence was by no means slavish: as Dickes put it, 'No one ever yet mistook a Crome for a Hobbema'.

It was through Thomas Harvey, too, that Crome became acquainted with his first successful professional artist, Sir William Beechey, R.A., who was living in London at the time, but paid a number of professional visits to his native town. He later wrote: 'Crome, when I first knew him, must have been about twenty years old and was a very awkward, uninformed country lad, but extremely shrewd in all his remarks upon Art, though he wanted words and terms to express his meaning. As often as he came to town he never failed to call upon me and to get what information I was able to give him upon the subject of that particular branch of Art which he had made his study. His visits were very frequent, and all his time was spent in my painting-room when I was not particularly engaged. He improved so rapidly that he delighted and astonished me. He always dined and spent his evenings with me.'

After a brief and abortive attempt to further his career in London, Crome set himself up as a drawing master in Norwich. The studio which he shared with Ladbrooke had to be given up in 1792 on his marriage to Phoeby Berney and the birth of their first daughter a month later. This did nothing to alter the friendship of the two artists, and Ladbrooke married Phoeby's sister Mary a year later. The first year of Crome's married life was bedevilled by illness, and in the same period he also, if mildly, caught the prevalent 'Wilson Fever'. He was still producing copies of Claudes for his patrons and compositions in the style of Wilson in 1798, before settling finally on the principal of 'Nature dignified by Art' on which his mature work was based. Although this study of Wilson was a diversion from the main direction of his art, he profited greatly from it by learning how to paint light, a knowledge which later became, as it were, his artistic hallmark.

By 1798 Crome had attracted his next important patron, the banker John Gurney of Earlham, to whose seven daughters he taught drawing. This connection, like that with Harvey, brought him into contact with a professional artist, this time John Opie the portrait painter, whose wife was a friend of the family. Opie, like Beechey, was able to help the young artist by example and advice, but it is a measure of Crome's genius that his own style shows no dependence on those of his early advisors. He also benefited from John Gurney's friendship by travelling through England and Wales with the family on their summer tours. His preferred method of teaching was to take his pupils into the country – 'This is our Academy' he cried – and to set them to work directly from nature, rather than through the sterile medium of copy books then in vogue.

Crome was now at the centre of a large group of friends, patrons and pupils. It was natural that they should seek a more formal association in which they could give expression to their mutual tastes and talents. Thus, on the 19th of February, 1803, the Norwich Society was founded 'for the purpose of an Enquiry into the Rise, Progress and present state of Painting, Architecture and Sculpture, with a view to point out the Best Methods of study to attain to Greater Perfection in these Arts'. Members could be of any profession or of none, although each candidate had to submit an example of his artistic work, and the prime purpose of the society was the reading of papers and informed discussions. Out of this, two

years later, at the instigation of Crome and Ladbrooke, arose the Norwich Society of Arts, with premises and a studio in an old house in Sir Benjamin Wrench's Court, in which an annual exhibition was held.

It was this society and exhibition which crystallised the position of Norwich as an independent art centre with its own School. Up to 1828, 323 individual artists contributed to the exhibitions, for the most part local people, and all the professional painters of the area came under the society's influence. As well as Crome and Ladbrooke, professional founder members included Daniel Coppin, Robert Dixon, Charles Hodgson and John Thirtle, as well as the engraver Bell and the architects Browne and Stone.

Since the remaining sixteen years of Crome's life were largely bound up with the history of the society and with the exhibitions, it might be as well to leave his biography at this point in order to glance at that of his most important colleague, before discussing his style and that of the school as a whole. Of all his fellow artists the only one whose genius could equal, or to some tastes surpass, that of Crome, was John Sell Cotman, who first exhibited with the Norwich Society in 1807.

Cotman, like Crome, came from pure Norfolk stock. His ancestors had been Yarmouth fishermen, but three members of his family had risen to become Mayors of the town between 1694 and 1759. John Sell's father was a draper, haberdasher, silk mercer and dealer in foreign lace in Norwich, and Dawson Turner, a partner in the Gurney bank and a patron who was to play a great part in encouraging the school, was a kinsman. Cotman was born in May 1782 and attended the grammar school, then under the enlightened headmastership of Dr. Forster – who later officiated at the marriages of Crome and Ladbrooke and became Vice President of the Norwich Society in 1805. In the British Museum there is a drawing of old houses in Mill Lane, Norwich, which J. J. Cotman attributed to his father and dated 1794, and which shows remarkable power for a twelve-year-old, even hinting at some of the mannerisms of the artist's mature style. With such evidence of talent as this, it is not surprising that Cotman's father made only a comparatively brief attempt to turn the boy into a draper before allowing him to go to London in 1799 in search of art.

Although based in Gerrard Street in Soho, Cotman seems to have undertaken extensive summer tours during the next few years, usually ending them with a stay in Norwich, where, in 1803, he even attempted to set up as a drawing master – with little success, owing to the well established position of such men as Crome, Ladbrooke and Hodgson. The tours included Surrey, North and South Wales, Devon and Cornwall, Lincolnshire and, perhaps the most important since it resulted in the valuable friendship and patronage of Francis Cholmely of Brandsby, Yorkshire. Cholmely's encouragement and advice helped him through the earliest of his lifelong series of depressions, and the family's friendship was one of the stabilising influences of his career. At the same time, he assiduously exhibited at the Royal Academy, despite a discouraging lack of enthusiasm on the part of the buying public. He also founded a sketching club, on the lines of Girtin's, which enabled him to benefit from the company of a young and congenial group of artists, and which cemented his friendship with John Varley – who also acted as an anti-depressant.

In 1806, on the way back from Durham and Lincolnshire, Cotman decided to make a further effort to set himself up as a drawing master in Norwich rather than returning to the uncertainties of the

capital. He hoped also to establish himself as a portrait painter, and Crome, who felt no resentment for this young competitor, sat for him. However, portraits were never in fact Cotman's strong suit, and of the twenty drawings which he sent to the Norwich Exhibition of 1807, only six were portraits. In the following year, when he was elected a member of the society, he submitted no less than sixty-seven works, of which by far the majority were again landscapes. He was still making regular tours about the country, and he was gradually realizing that his best path to success was to concentrate on his undoubted talent for architectural drawing and his ability to raise topography to the level of pure and original landscape art.

On 6 January 1809, Cotman married Ann Miles, the daughter of a Norfolk farmer. The relationship provided a steadying influence in his life, but it also meant renewed efforts to establish his career and financial affairs. It was at this time that he first produced his scheme for a circulating collection of drawings. This was, so to speak, an 'open university' to the usual academic practice of drawing masters. Cotman would deliver a drawing to a subscriber (at one guinea per quarter) and, having given brief instructions, leave him to copy it at leisure. This allowed him a far wider circle of pupils than would have been the case through formal lessons alone. In the following years, having been elected Vice-President of the Norwich Society in 1810, he busied himself with oil painting and then, in 1811, very much more successfully, with etching. In his prints, and above all in his soft-ground etchings, Cotman was able to achieve a perfect marriage between the brilliance of his architectural and topographical drawings and the print-maker's art.

While Crome and Robert Dixon had already published very beautiful soft-ground etchings of Norfolk scenery and buildings, Cotman's publications, culminating in the *Architectural Antiquities of Normandy* and the *Liber Studiorum*, must take the highest place in Norwich print-making for their ambitious variety and scope. The first was the fruit of three journeys to Normandy undertaken in 1817, 1818 and 1820 at the instigation of Dawson Turner, and the 100 folio plates with their contrasted elaboration of architectural detail and simplicity of surroundings were an immediate and substantial success when they were published in 1822.

At the same time, John Crome's life had continued in its comparatively uneventful course. Only two events took place which in any way ruffled the orderly pattern of his last fifteen years. One was the visit he, like so many other artists, paid to Paris in 1814 to see the vast collection of looted treasures brought together by the Napoleonic armies. The second was the secession of Robert Ladbrooke and six other members from the Norwich Society in 1816.

The 1814 journey, Crome's only venture abroad, was undertaken in the company of two of his Norwich colleagues, William Freeman, an artist and frame maker, and Daniel Coppin, a very competent landscapist. Crome thoroughly enjoyed Paris and the varied society gathered there, although he was shocked by the prices and haggling in the French shops. He collected much material for later use and called on at least one French artist, David, presumably with a view to improving his own figure drawing.

The troubles which led to the secession began in 1815 with an agitation by the artists who were not drawing masters to exclude amateurs from membership of the society. In this they were supported by the President of the year, James Sillett, the still life painter and miniaturist. This culminated in the

secession of the following year, and two exhibitions were mounted, each claiming the legitimate line of descent. Apart from Ladbrooke, who seems to have resented the predominance of his old friend and brother-in-law, and Sillett, the most important of the rebels was John Thirtle, who was, after Cotman, his brother-in-law, the best of the Norwich watercolourists. However, the public of Norwich could not support two exhibitions, and after three years the attempt collapsed, the rebels gradually making some sort of peace with the parent society.

Crome's last years were passed in relative peace and prosperity, surrounded by his family and pupils, with his eldest son, John Berney Crome, taking over much of his teaching work and the leading place in the society, and being elected President for 1819. Painting came so naturally to Crome that even in his final delirium in April 1821 he made convulsive movements as if handling a brush. With almost his last words to his son he summed up the whole of his artistic philosophy and practice: 'John, my boy, paint; but paint for fame; and if your subject is only a pig sty – dignify it!'

In the meantime Cotman's life continued upon its jerky way. In 1811, largely because of Crome's unwillingness to continue as a supplier of architectural and archaeological drawings to Dawson Turner and as drawing master to his daughters, Cotman removed to Yarmouth and took over these functions. It was not until 1824 that he broke loose from Turner's benevolent but exacting patronage and returned to Norwich. In the following year, the society was dissolved for lack of premises, although it was revived in 1828 and limped along for some time under the title of 'The Norfolk and Suffolk Institute for the Promotion of Fine Arts'. During this second Norwich period, which lasted until 1833, Cotman was subject to recurring bouts of depression, from one of which he was possibly only saved by his friend John Varley who forced his way into the sick room and informed Cotman that he could not die yet since the stars gave him another ten years. He made various efforts to bring his style more into line with popular taste, but never really succeeded, relying, as always, on his income as a drawing master to support his family – and the family were increasingly brought into service to supply drawings for the circulating collection.

Then, in 1833, at the instigation of Dawson Turner, supported by J. M. W. Turner, who, when asked his opinion, cried: 'Whom are you to elect? I am tired of saying what I say again. Cotman! Cotman! Cotman!,' the artist was elected Professor of Drawing at King's College London. With three of his children, John Joseph, Ann and Alfred to help him, he threw himself into a new career in the metropolis and a new, rather garish, blue and gold style. John Joseph proved too much of an individualist to work well with his father, and after a short while changed places with his elder brother, the more tractable Miles Edmund, who had remained in the practice at Norwich; but the others produced many copy drawings to which their father's only contribution was a signature. Amongst his pupils was the nine year old Dante Gabriel Rossetti, although Cotman could hardly be claimed as an influence on his later work.

In his last years, in yet another attempt at popular success, Cotman tried to join the school of costume and historical painting which had proved so profitable to the Cattermoles, Nash and Bonington. Some of the less elaborate of these productions, usually lightly coloured single figure drawings such as *The Philosopher, Columbus,* or *The Student,* are interesting and quite attractive; other more elaborate works were judged 'garish and superficial' at the time, and unfortunately the judgement must still stand.

In 1841, however, he made a last visit to Norfolk, and the drawings resulting from this trip, done largely for his own enjoyment, are an expression of Cotman's style and genius at its best. They provide a fitting end to his career, for he was still working on finished versions of them when he died the following July.

Crome and Cotman were the two great influences and upholders of the school of artists which formed about them. Although they worked from the same starting point, the portraiture of nature, they had little impact on each other, for their ways of thinking and methods of working were too different. Crome was the teacher who placed nature before his pupils and encouraged them to portray it as they saw it, Cotman the master who taught his pupils to copy a very personal vision of the world. Both were in different ways innovators, and if today a work by Crome has a rather old-fashioned air when placed beside a Cotman, it should be remembered that Crome's was the greater influence since he concentrated on getting the best from his associates rather than on moulding them, and also that his power of handling light and atmosphere were a revelation to his own time. Some of their followers drifted away from them. Others, such as Thirtle in his kinship with de Wint, benefited from outside influences, and artists from beyond Norwich, like Muller or Harding, acknowledged their debt to the Norwich masters. In fact, the school, although local in origins, was never parochial in outlook, and ultimately, by its very existence, it enhanced British painting as a whole; for by their concern with dignifying, rather than re-arranging, what they saw, or forcing it to conform to arid formulae, the Norwich artists acted as midwives for the freer and more realistic style of landscape painting of the nineteenth century.

Bibliography

Binyon, L. *John Crome and John Sell Cotman*, 1897
Clifford, D. P. *Watercolours of the Norwich School*, 1965
Clifford, D. & T. *John Crome*, 1968
Collins Baker, C. H. *Crome*, 1921
Cotman, A. M. & F. W. Hawcroft, *Old Norwich*, 1961
Cundall, H. M. *The Norwich School*, 1920
Day, H. A. E. *East Anglian Painters*, 1968–9
Dickes, W. F. *The Norwich School of Painting*, 1905
Theobald, H. S. *Crome's Etchings*, 1906

See also the catalogues and publications of the Castle Museum Norwich, in particular *Henry Bright*, 1973 and *The Members of the Norwich Society of Artists 1805–1833* by M. Rajnai.

John Crome

1 *The top sawyer* attributed to John Crome 58.8 × 71.1 cm oil on panel (Watney Mann East Anglia Ltd.)

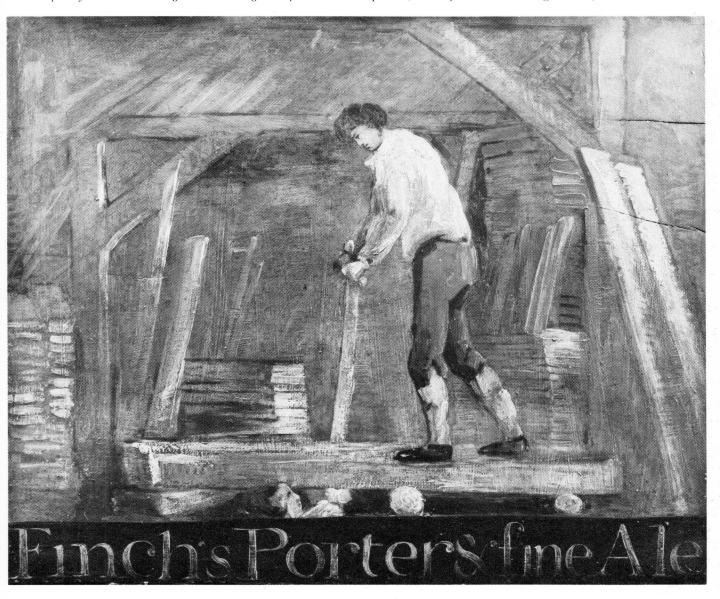

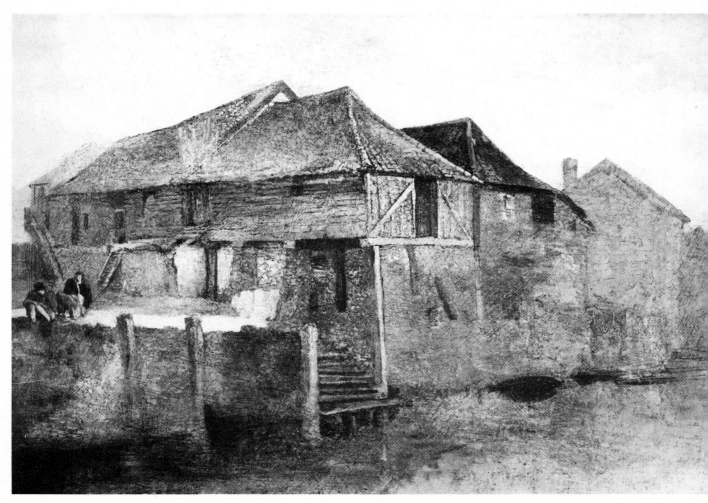

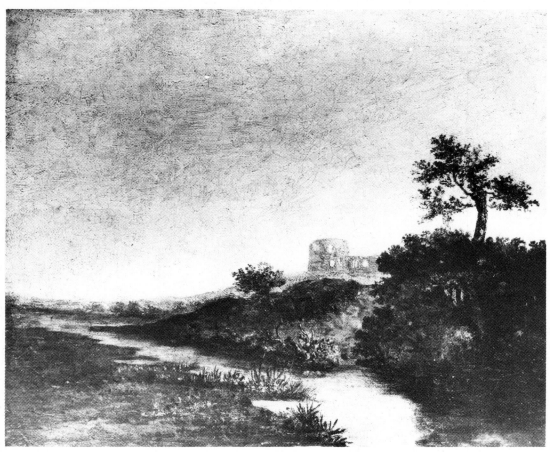

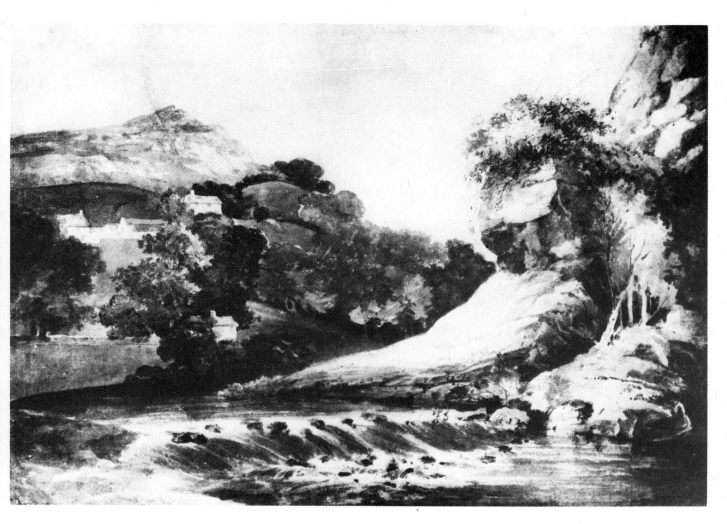

4 *River and rocks* John Crome 38.9 × 54.6 cm watercolour (Castle Museum, Norwich)

2 *Cottages on the Wensum, Norwich* c.1820 John Crome 26.9 × 37.9 cm oil on panel (from the collection of Mr. and Mrs. Paul Mellon)

3 *A castle in ruins – morning* c.1808 John Crome 29.4 × 34.3 cm oil on canvas (Castle Museum, Norwich)

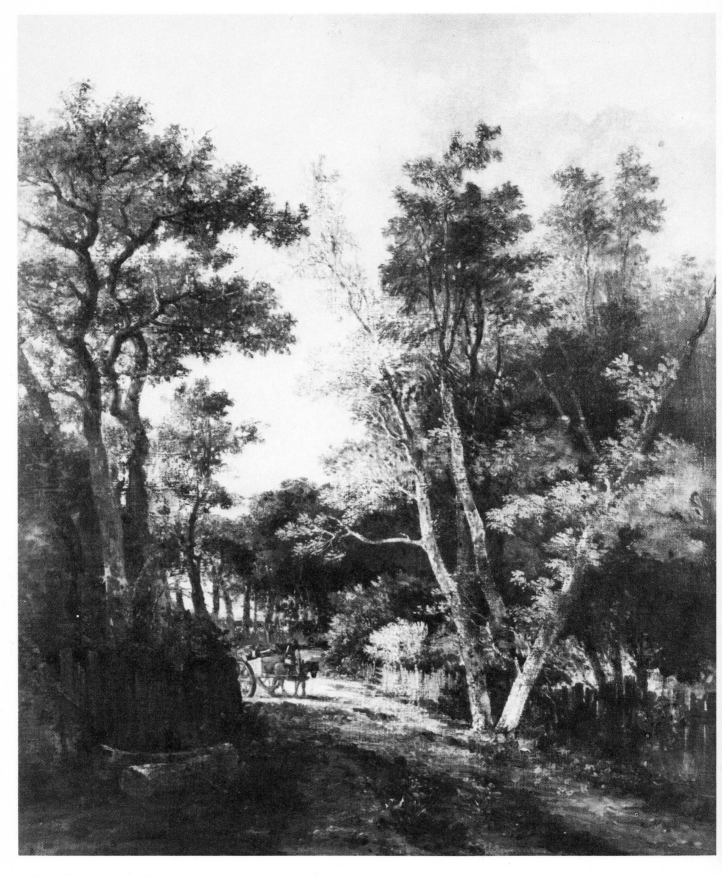

5 *Catton Lane* c.1808–1815 John Crome 67.4 × 56.4 cm oil (private collection)

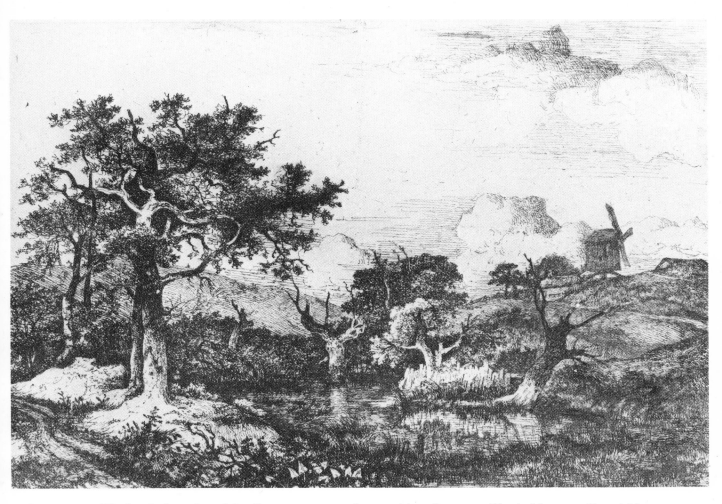

6 *Deepham near Hingham* before 1813 John Crome 15.3 × 22.8 cm etching, first state (Castle Museum, Norwich)

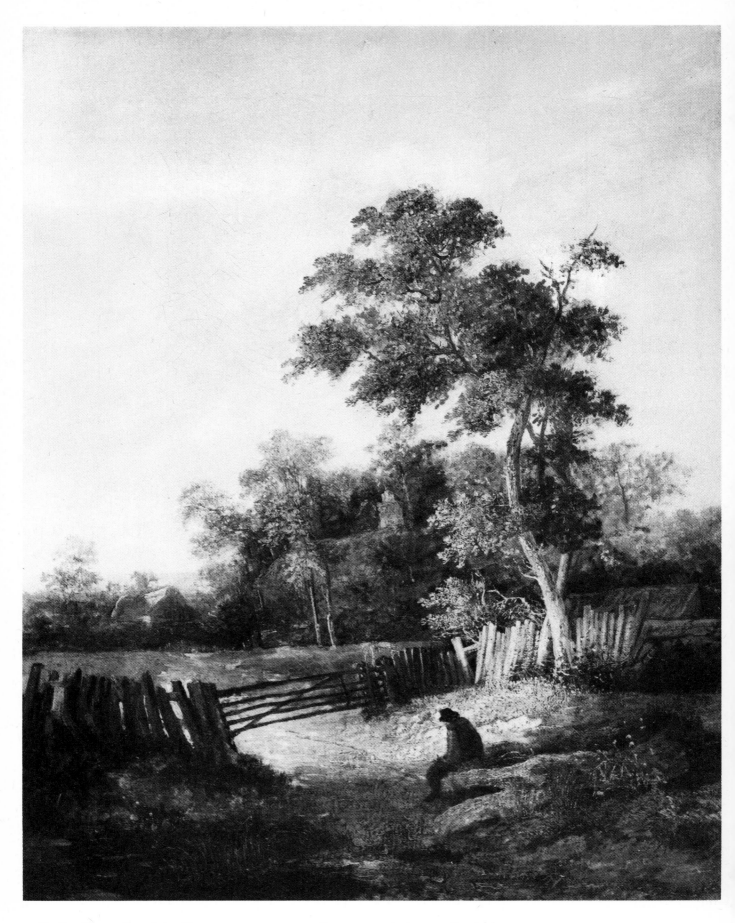

7 *Harling Gate* c.1812 John Crome 50.2 × 39.2 cm oil on canvas (private collection)

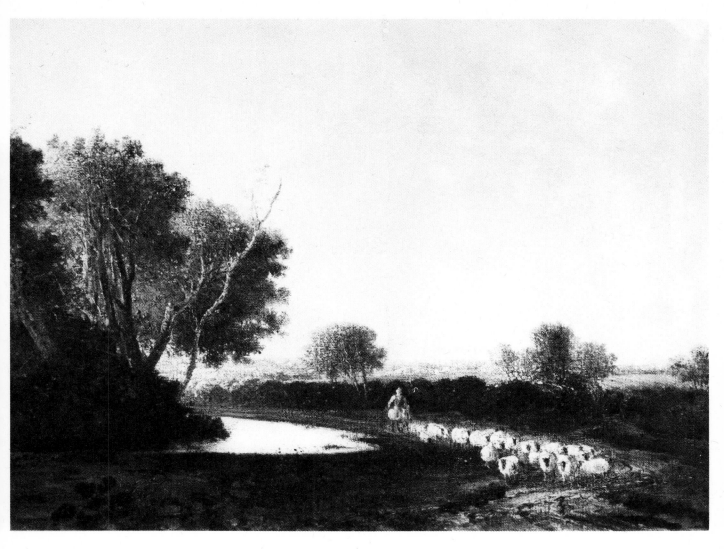

8 *Return of the flock* 1810–1813 John Crome 44.1 × 58.8 cm oil on canvas (private collection)

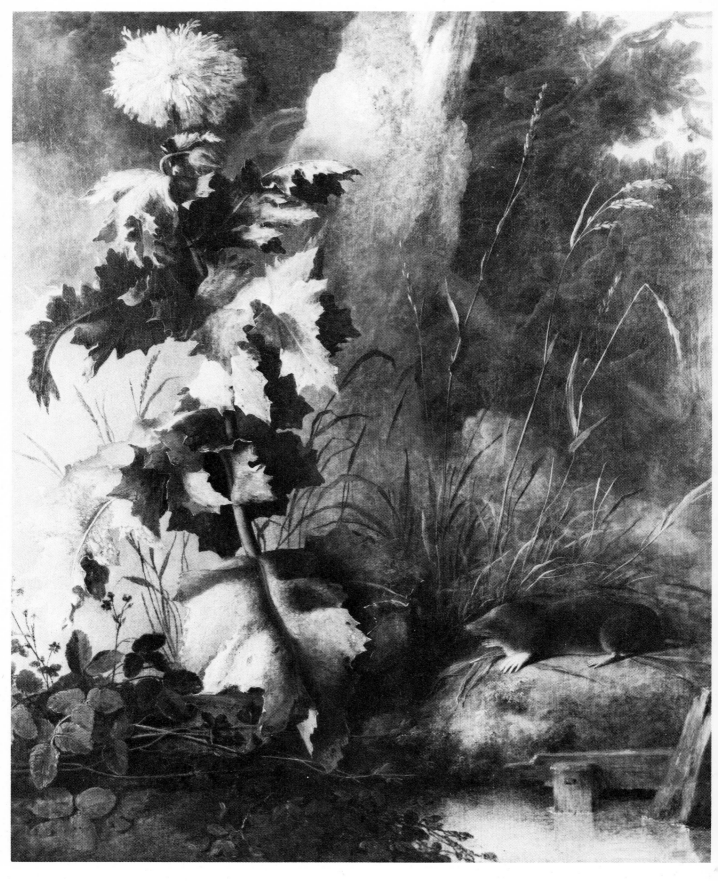

9 *Egyptian poppy and garden mole* John Crome dimensions not known oil (from the collection of Mr. and Mrs. Paul Mellon)

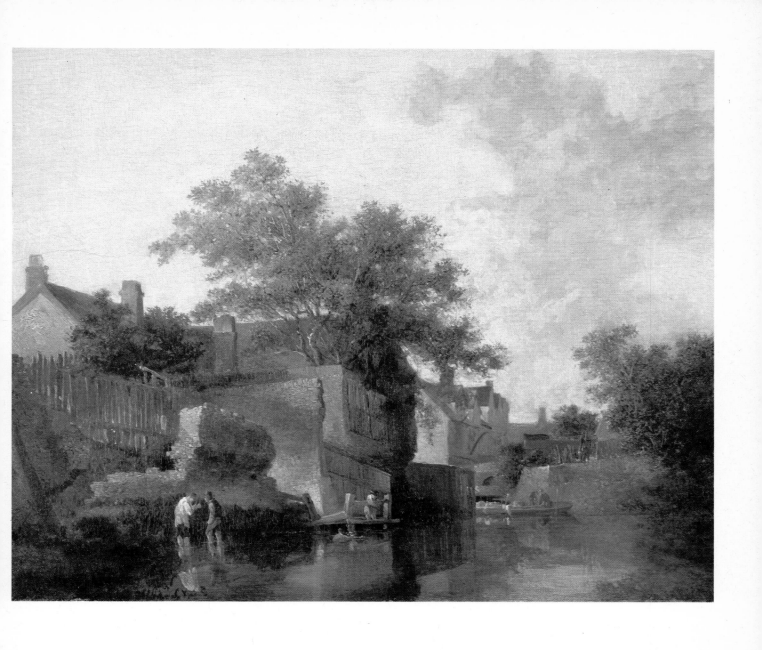

I *New mills: men wading (Norwich)* John Crome 27.6 × 34.3 cm oil on panel (Castle Museum, Norwich)

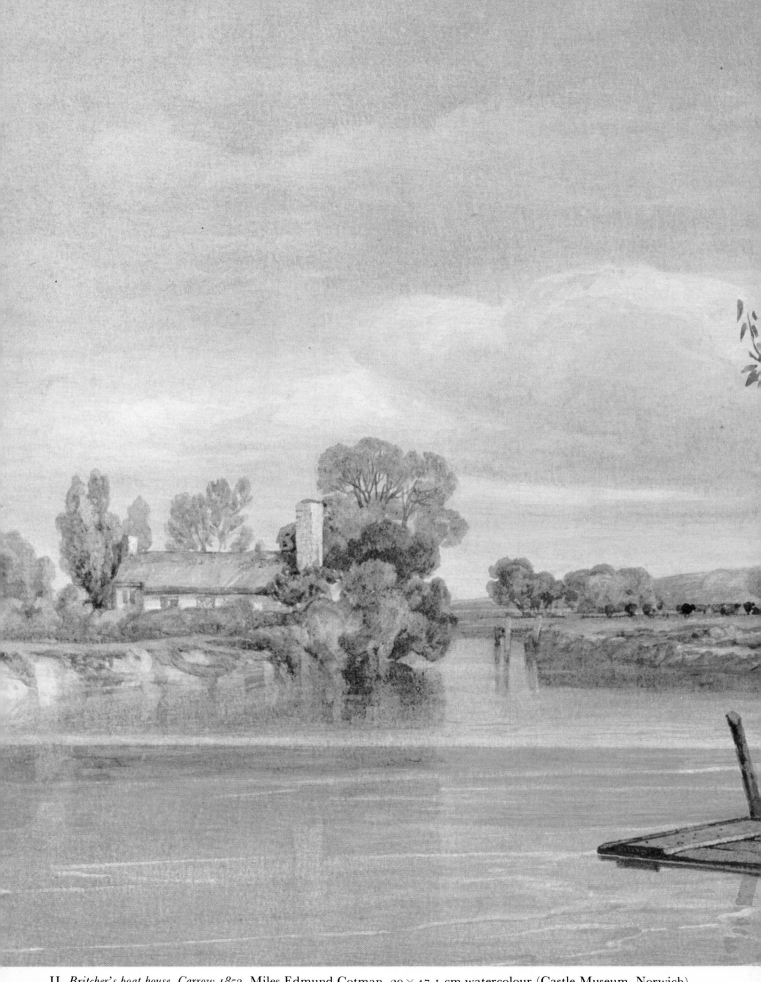

II *Britcher's boat house, Carrow 1853* Miles Edmund Cotman 29 × 47.1 cm watercolour (Castle Museum, Norwich)

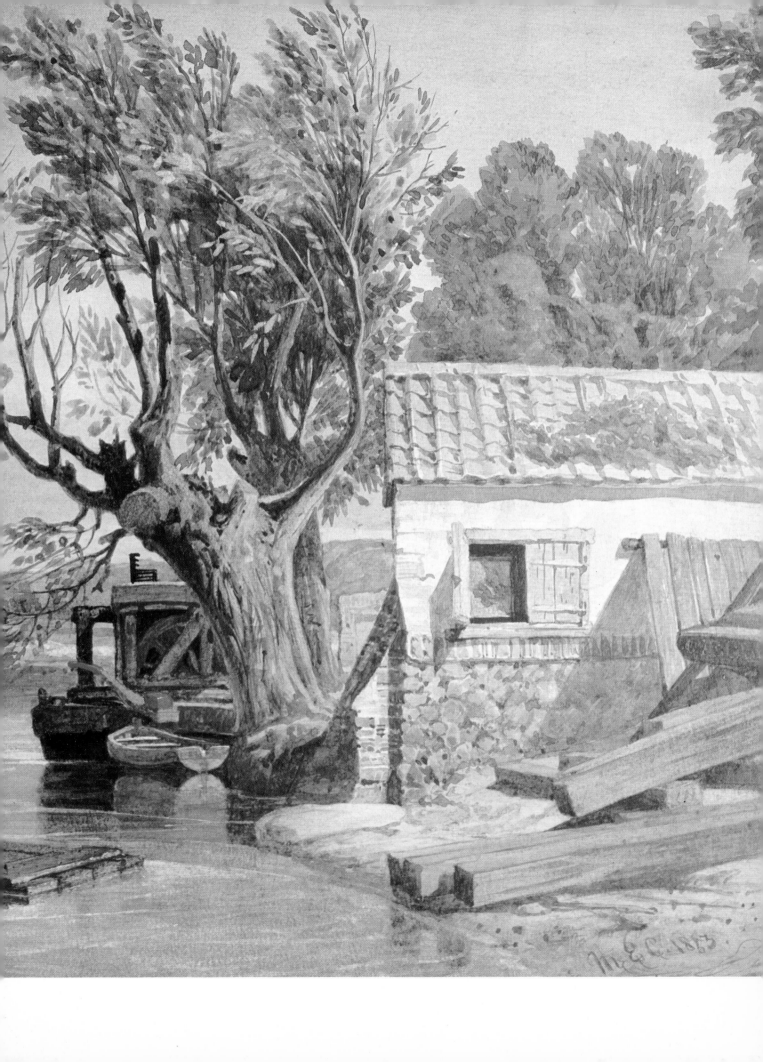

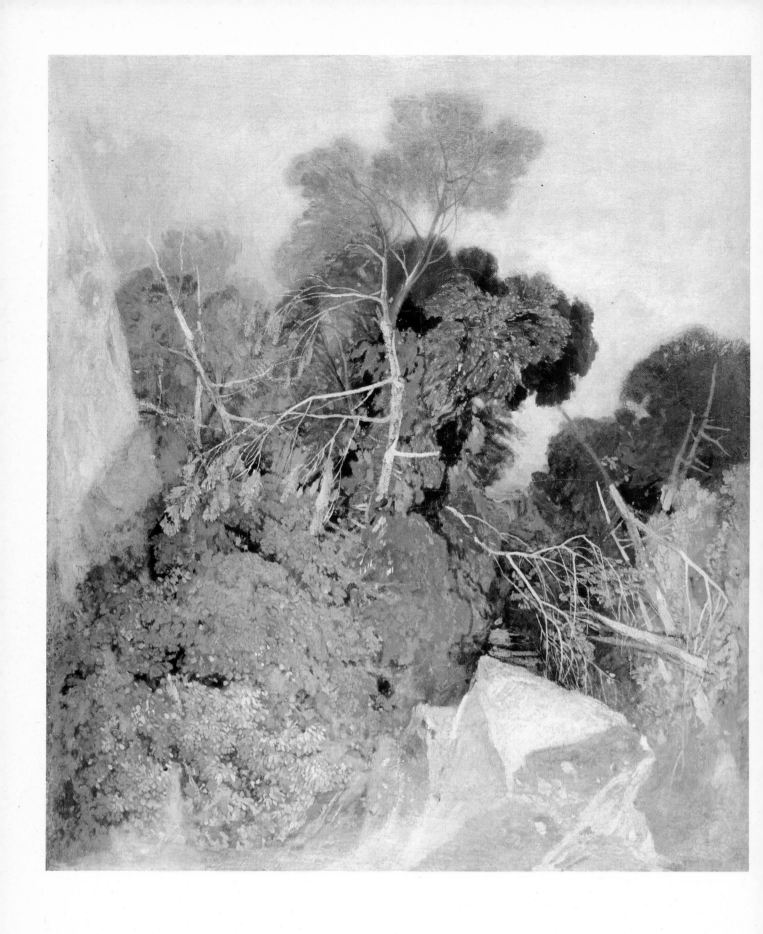

III *Silver birches* John Sell Cotman 76.3 × 63 cm oil on canvas (Castle Museum, Norwich)

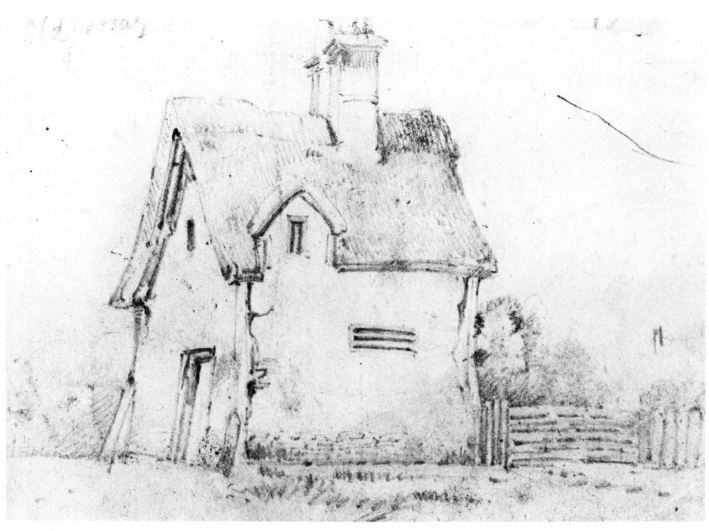

10 *Old cottage with gate on right* John Crome 12.7 × 16.7 cm
pencil (Castle Museum, Norwich)

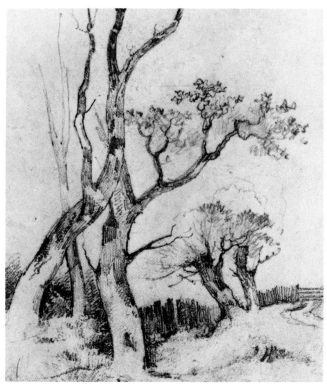

11 *The blasted oaks* c.1808 John Crome 16.5 × 12.9 cm pencil
(Castle Museum, Norwich)

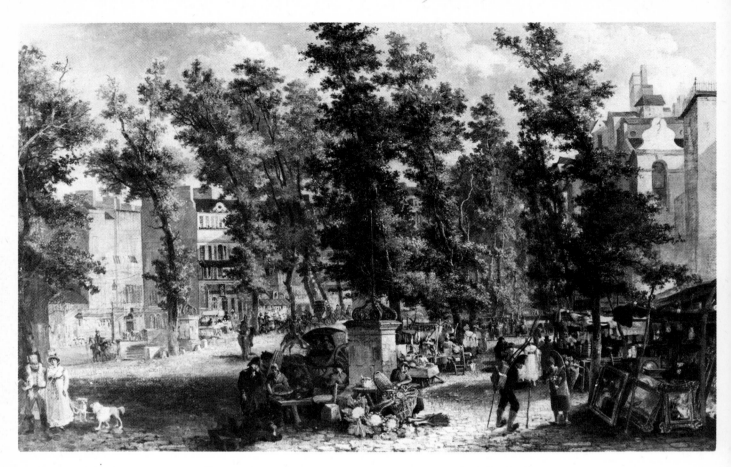

12 *Boulevard des Italiens* 1814–1815 John Crome 52.7 × 83.3 cm oil on canvas (Mr. R. Q. Gurney)

13 *The study of a burdock* c.1813 John Crome 52.7 × 40.4 cm oil on panel (Castle Museum, Norwich)

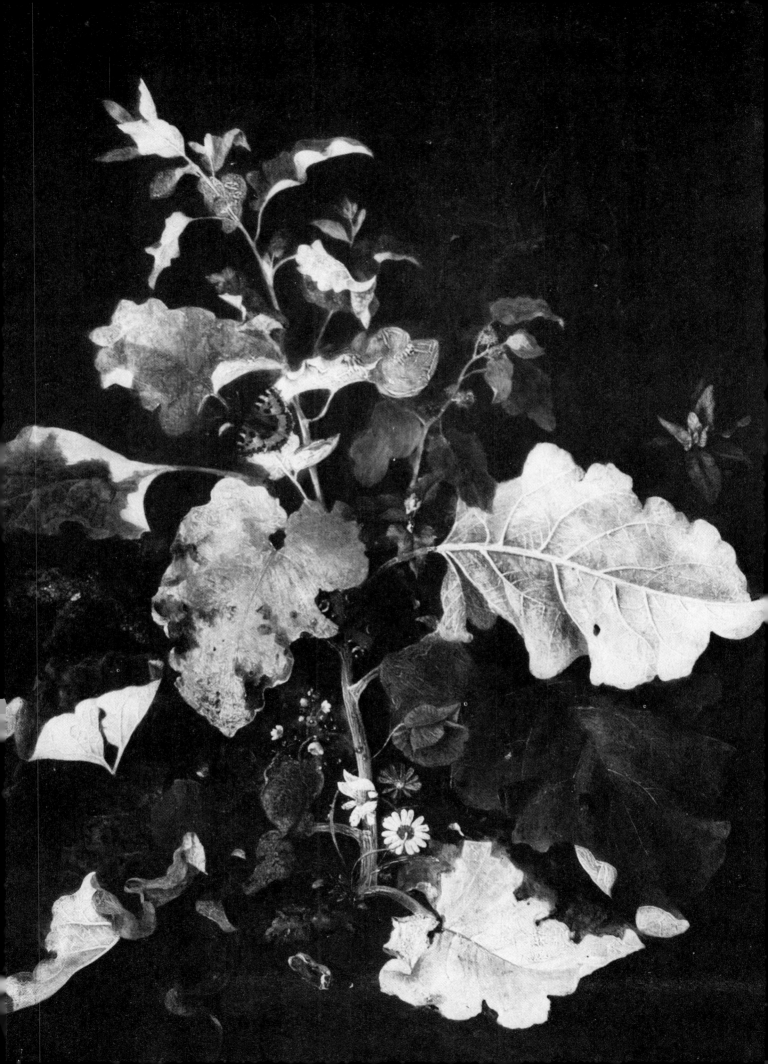

John Sell Cotman

14 *A young merchant adventurer* John Sell Cotman 26.3 × 17.3 cm pencil and watercolour (private collection)

15 *An arch in Norwich cathedral* John Sell Cotman 23.9 × 16.5 cm pencil and grey wash (private collection)

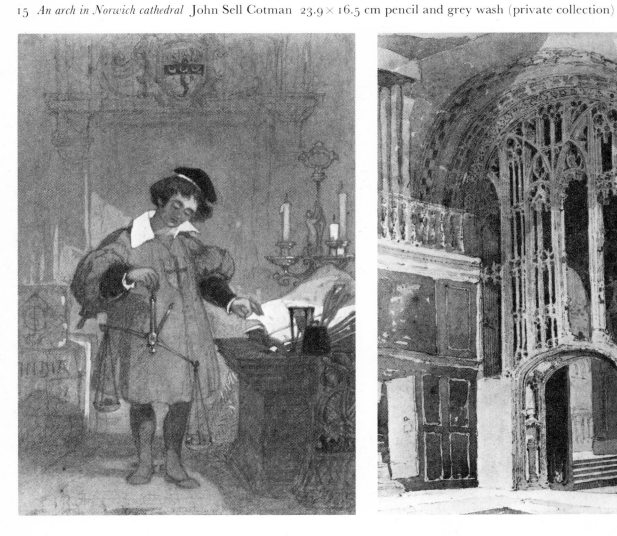

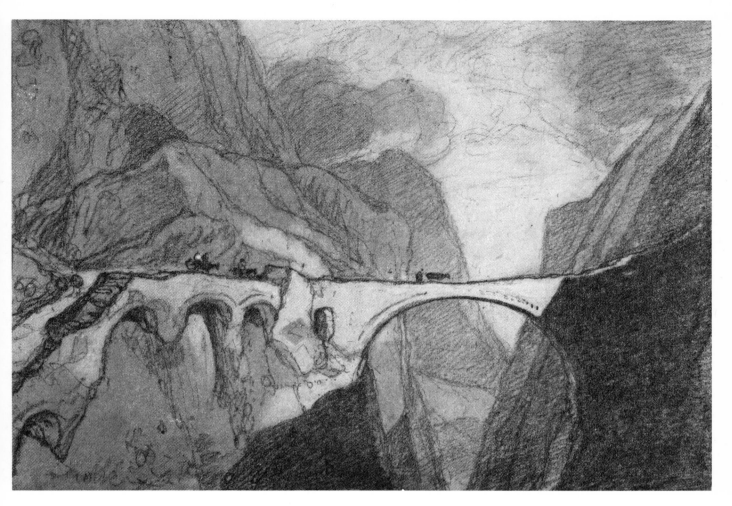

16 *Travellers crossing a bridge over an Alpine gorge* John Sell Cotman 15.3 × 27.7 cm pencil and yellow wash heightened with white on brown paper (private collection)

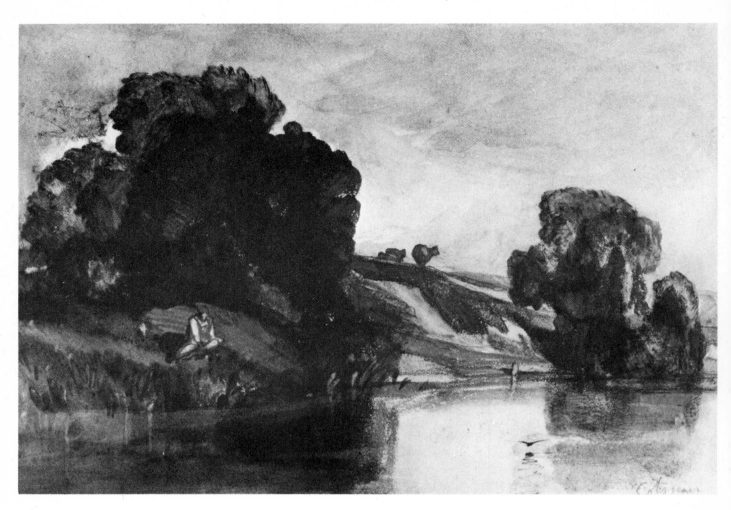

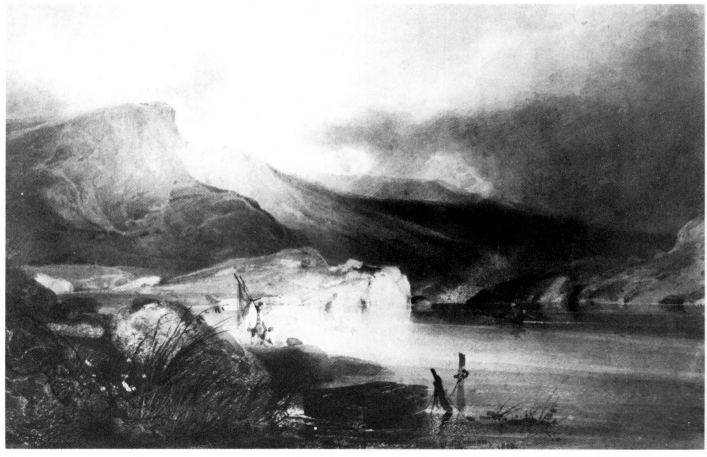

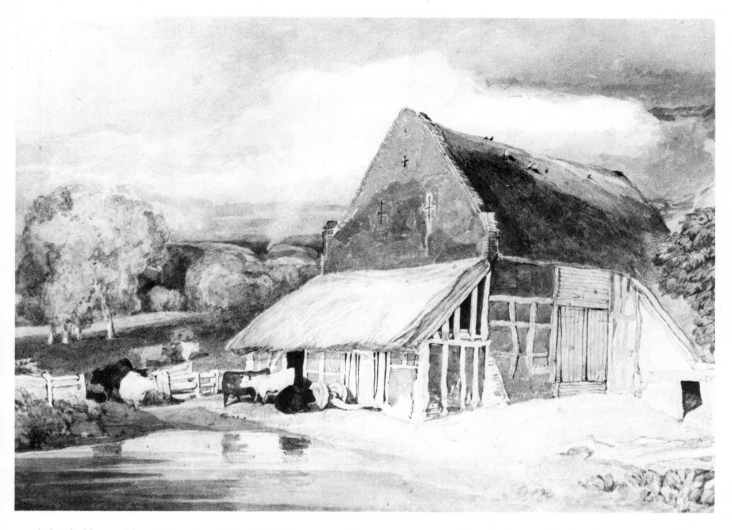

19 *A thatched barn with cattle by a pond* John Sell Cotman 22.8 × 31.9 cm watercolour (private collection)

17 *Postwick Grove, Norfolk* John Sell Cotman 17.8 × 26.7 cm pencil and watercolour (private collection)

18 *Llyn Ogwen* John Sell Cotman 27.6 × 43.5 cm watercolour (private collection)

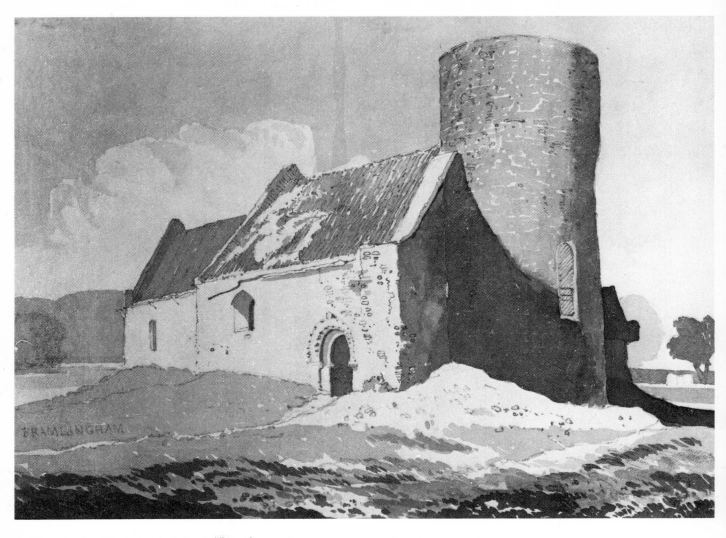

20 *Framlingham Earl church* John Sell Cotman 18.9 × 25.7 cm pencil and grey wash

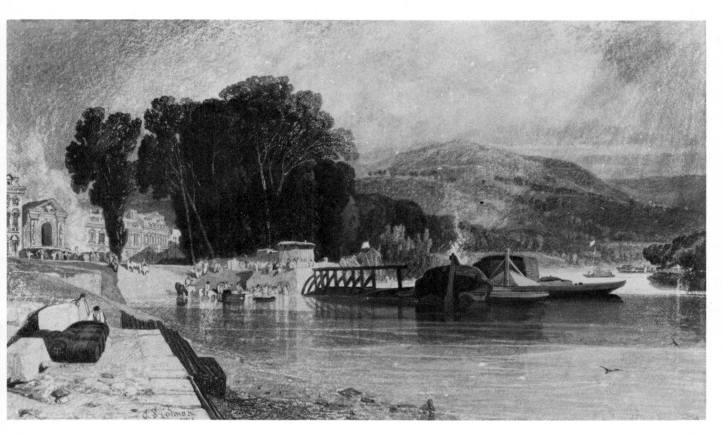

21 *Mount Saint Catherine, Rouen* John Sell Cotman 26.9 × 46.6 cm watercolour (private collection)

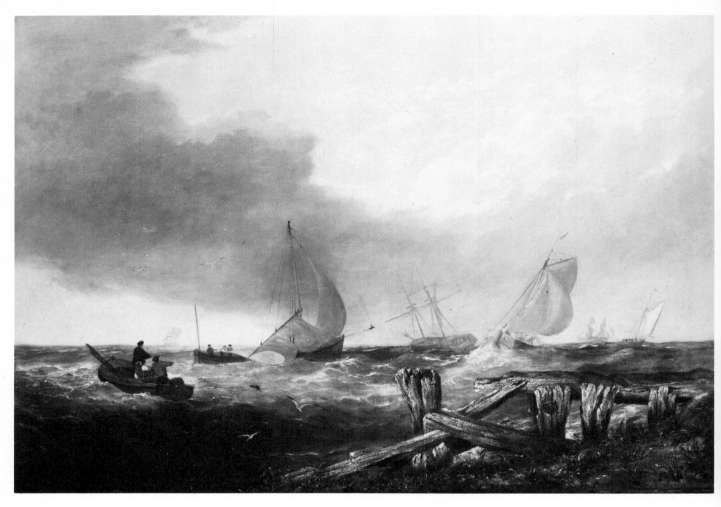

22 *Shipping off shore* John Sell Cotman 45.7 × 106.7 cm oil (private collection)

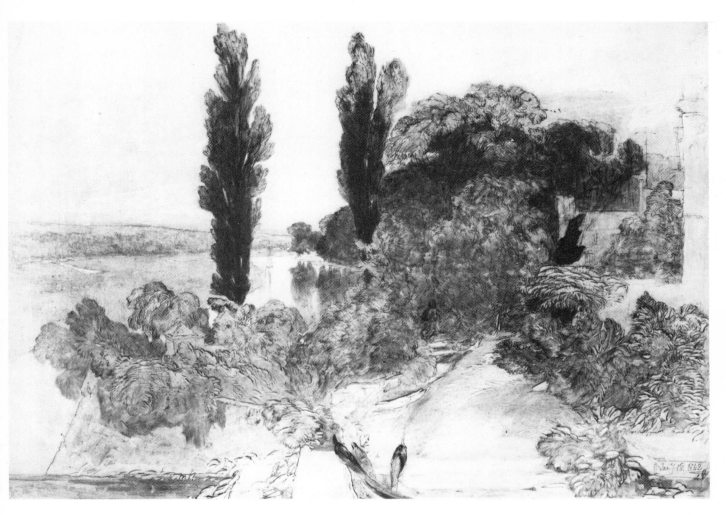

23 *From my father's house at Thorpe* John Sell Cotman 61.3 × 90.7 cm oil on canvas (private collection)

Richenda Gurney

24 *Eastham* Richenda Gurney 22.5 × 32.6 cm (Alec M. Cotman)

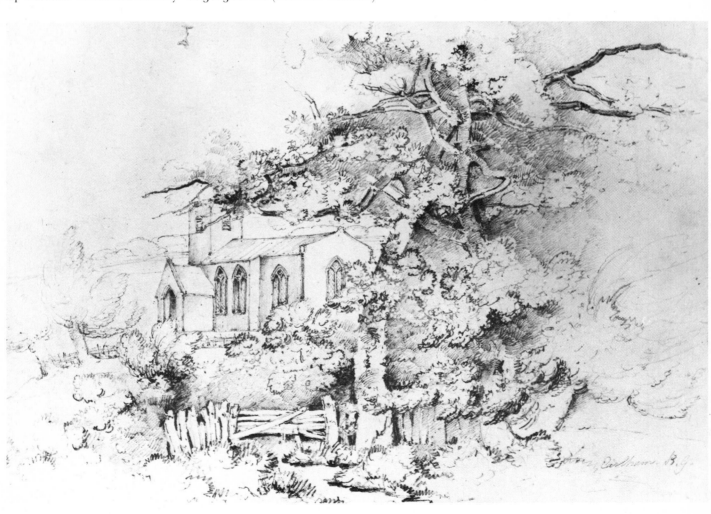

The Hodgsons

Charles Hodgson, whose dates are unknown, was a schoolmaster who gradually moved from mathematics to drawing. He was one of the founders of the annual exhibitions and was chiefly known for his faithful views of Norwich buildings. His son, David (1798–1864) followed very much in the same paths, being drawing master at the Norwich Grammar School as well as a visiting teacher, a faithful follower of Crome, and a competent and even at times rather inspired delineator of Norwich.

25 *Guildhall Hill, Norwich* Charles Hodgson dimensions not known oil on panel (private collection)

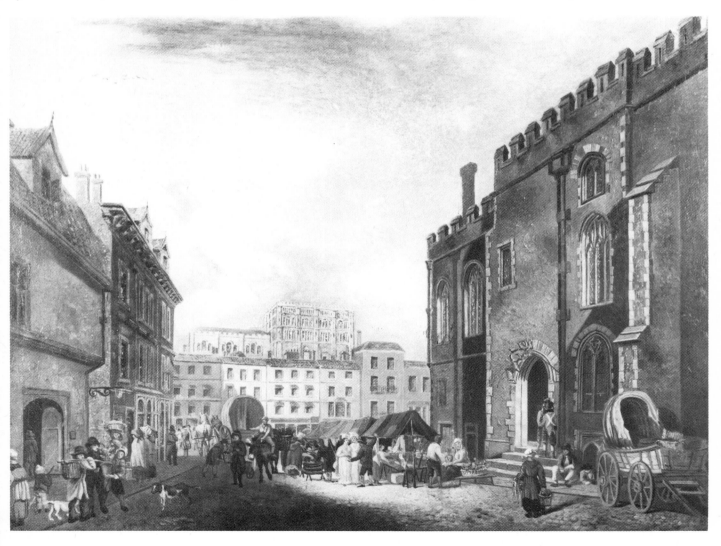

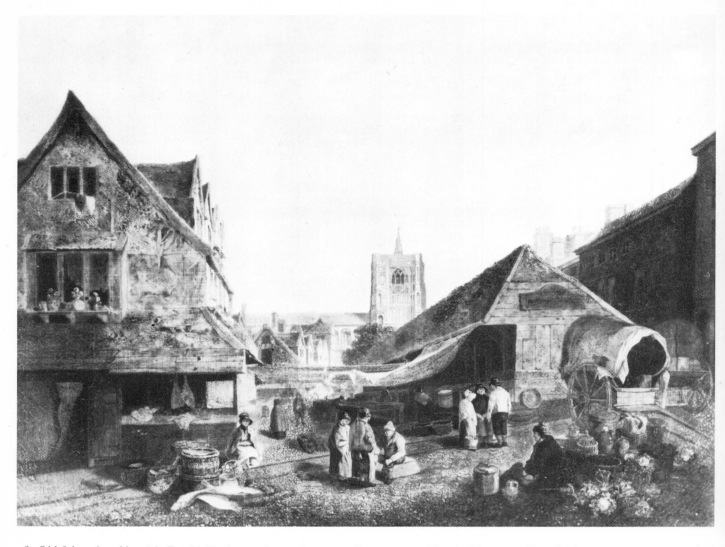

26 *Old fishmarket, Norwich* David Hodgson 65.7 × 84.5 cm oil on canvas (Castle Museum, Norwich)

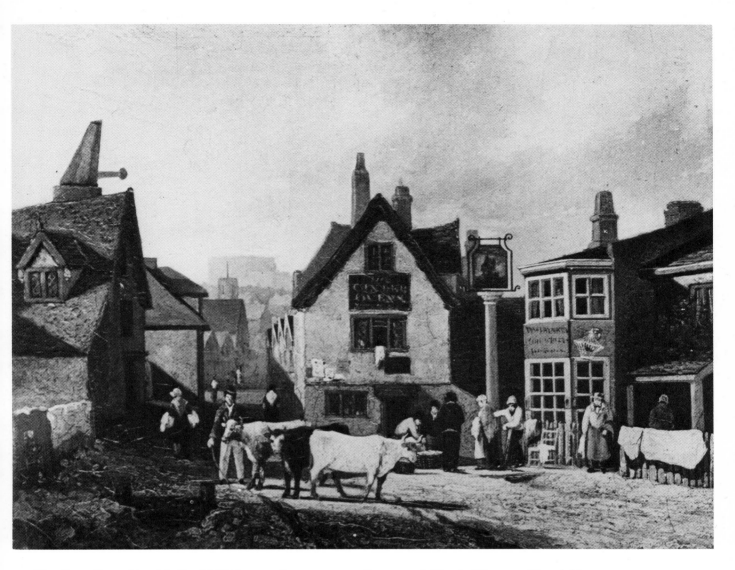

27 *King Street Gates, Norwich* David Hodgson 16.5 × 21.4 cm oil on panel (Castle Museum, Norwich)

The Ladbrookes

Robert Ladbrooke (1770–1842), like Crome, led a largely uneventful life. Of his early career nothing need be said that has not already been touched on above. He was the last of the secessionists to return to the Norwich Society in 1823, and returned only as an exhibitor rather than a full member. His last years were much occupied by the production of *Views of the Churches of Norfolk* – all seven hundred of them – in collaboration with his son John Berney Ladbrooke. Beside a volume by Cotman or the etchings of Crome or Dixon, these are poor indeed. Technically he was an excellent painter, but he lacked the attention to detail which marks his brother-in-law's work. Three of his sons, Henry, John Berney, and Frederick became painters, but only the second attained any great distinction, producing landscapes rather in the manner of his uncle John Crome.

28 *Landscape – the river Yare from Postwick Grove* Robert Ladbrooke 20.8 × 30.6 cm oil on panel (Castle Museum, Norwich)

29 *Glymllffes Bridge, North Wales* Robert Ladbroke 52.7 × 38.6 cm watercolour (Castle Museum, Norwich)

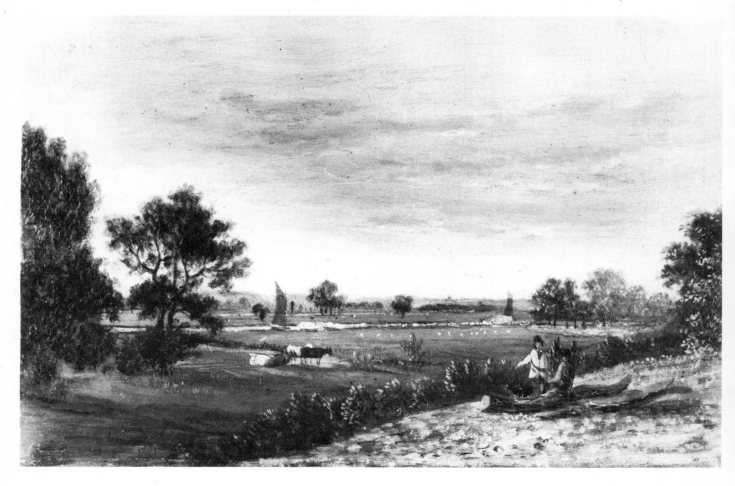

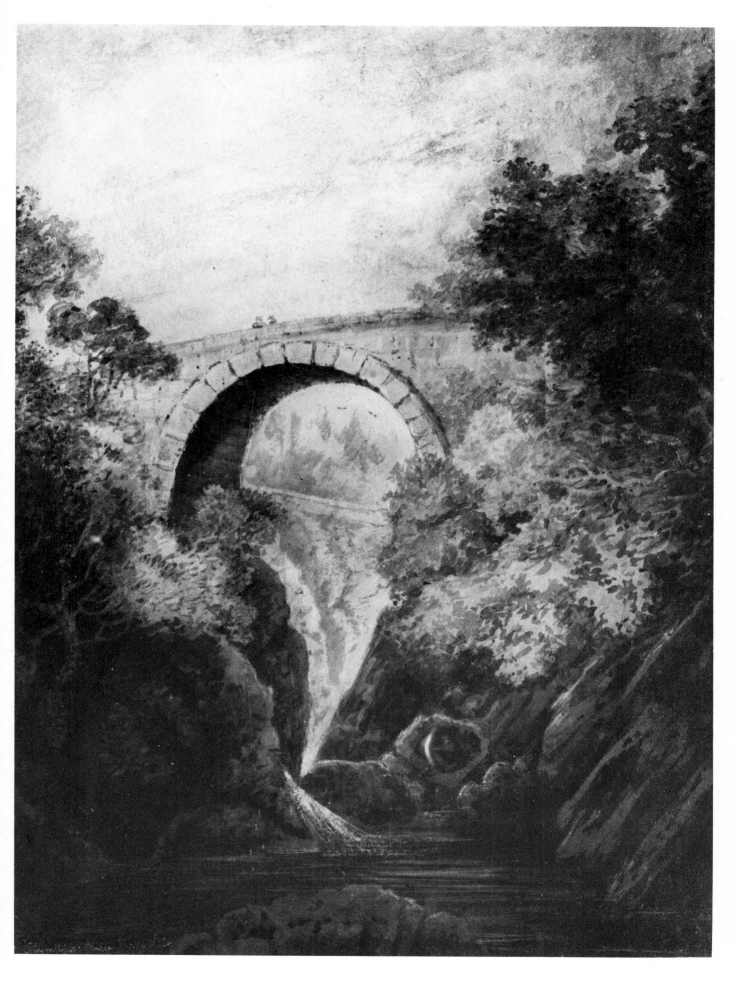

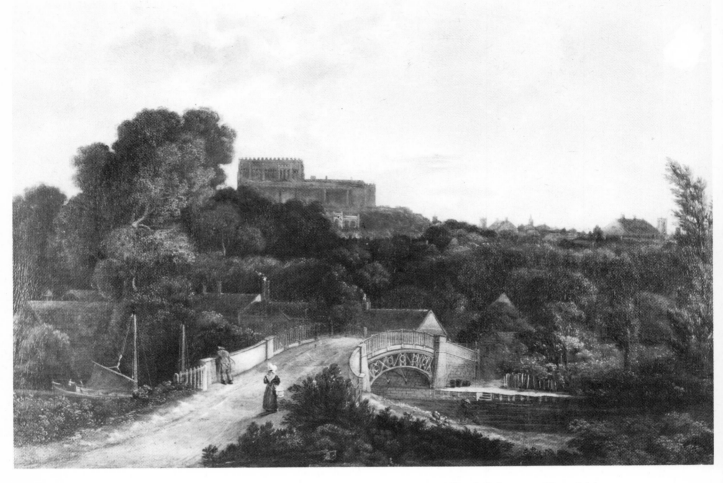

30 *Foundry Bridge, Norwich* Robert Ladbrooke 64.3 × 94.9 cm oil on canvas (Castle Museum, Norwich)

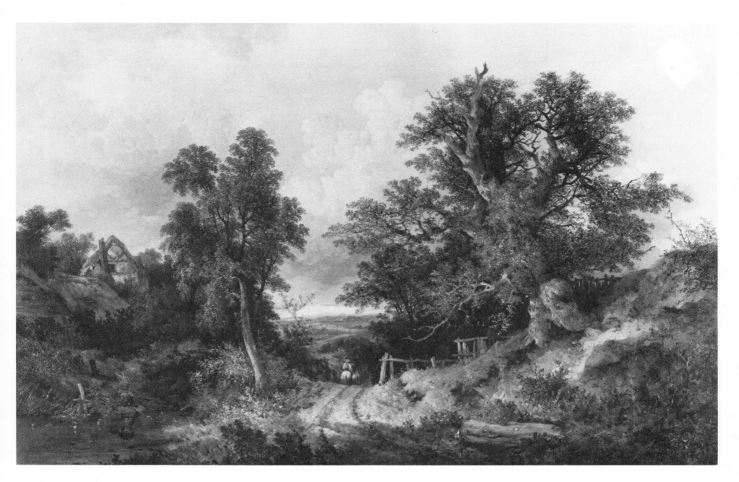

31 *Lane scene 1874* J. B. Ladbrooke 57.1 × 87.3 cm oil on canvas (Castle Museum, Norwich)

John Thirtle

John Thirtle (1777–1839) was born in Norwich but sent to London as an apprentice frame maker. In about 1800 he returned and set up business on his own account, combining framing, carving and gilding with teaching, drawing and miniature painting. Until the secession he was a regular contributor to the exhibitions, and indeed with the removal of his friend and brother-in-law, Cotman, to Yarmouth, he was for some years the only major watercolourist among the exhibitors. He was considerably influenced by Cotman, and his style also seems to owe something to Varley. Cotman also influenced his methods of teaching, with the result that there are many copies of his drawings.

32 *River scene with rainbow (King Street, Norwich)* John Thirtle 38.9 × 61.5 cm watercolour (Castle Museum, Norwich)

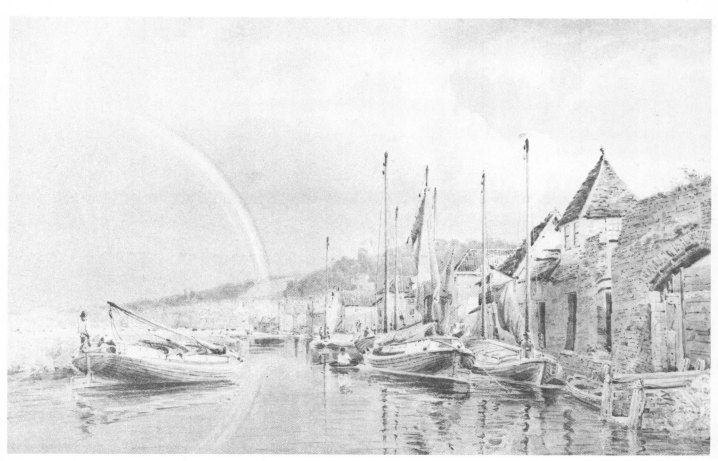

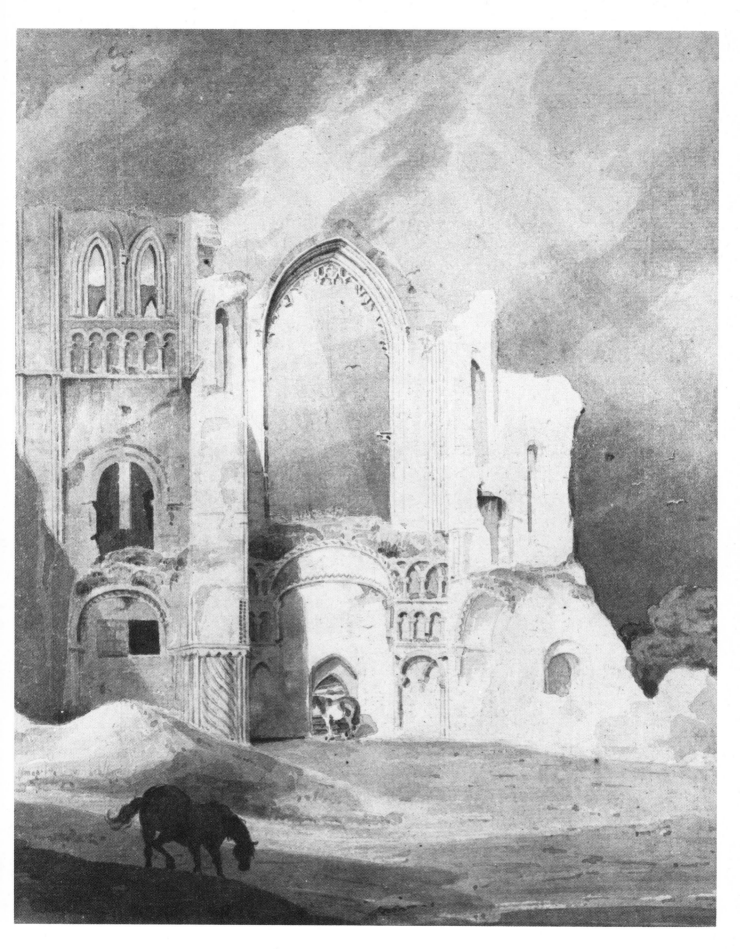

33 *Castle Acre Priory* c.1804 John Thirtle dimensions not known watercolour (private collection)

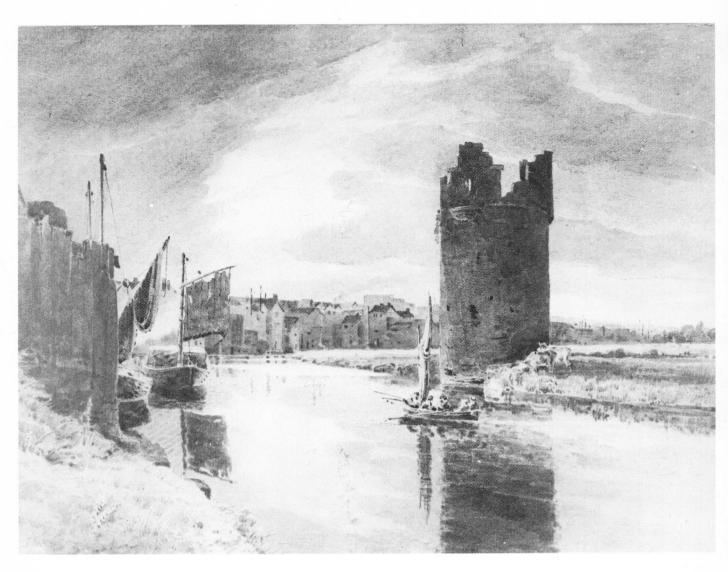

34 *The Devil's Tower, Norwich* John Thirtle 29.2 × 41.4 cm watercolour (Castle Museum, Norwich)

35 *Tombland* John Thirtle 33.1 × 52.1 cm watercolour (Castle Museum, Norwich)

36 *Timber yard and Norwich cathedral from the north* John Thirtle 23.3 × 32.5 cm watercolour (Geoffrey Allen)

46

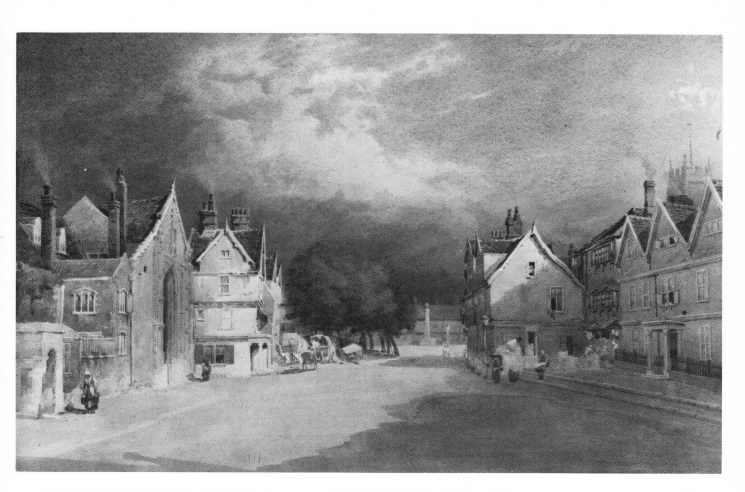

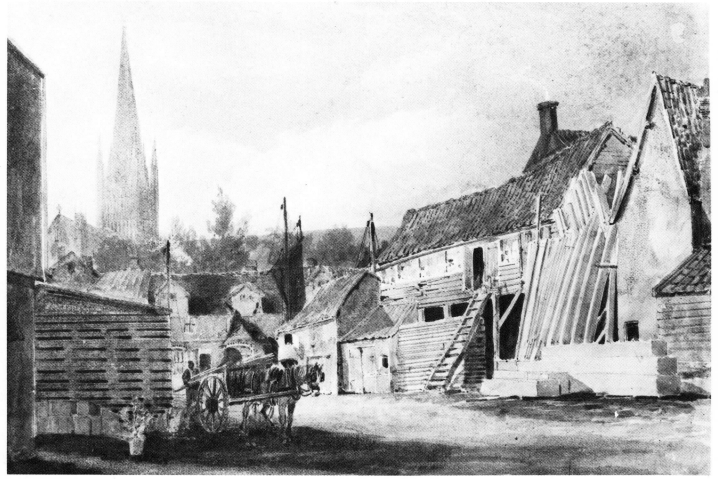

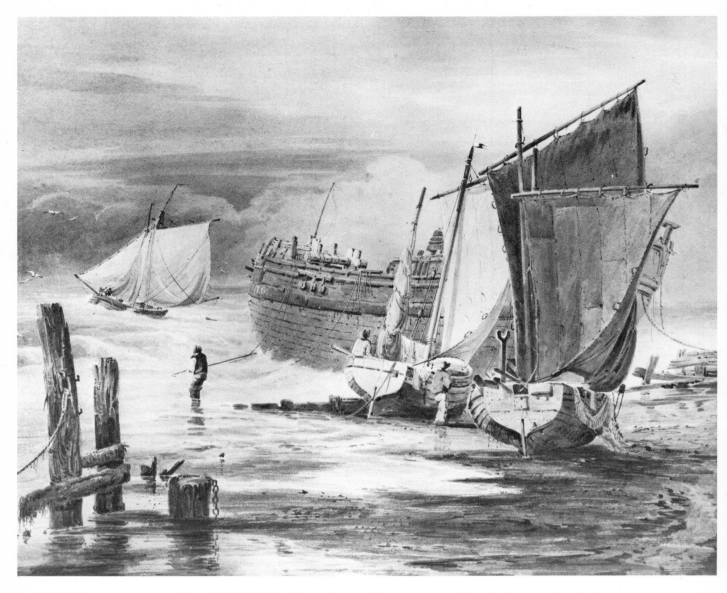

37 *Fishing boats, storm approaching* John Thirtle dimensions not known watercolour (private collection)

Robert Dixon

Robert, or William Robert, Dixon (1780–1815) was a scene painter at the Norwich Theatre as well as a teacher of drawing. For the first five years of the Norwich exhibitions he was a regular contributor, and he was elected Vice President in 1809. He is chiefly notable for the thirty-eight soft-ground etchings entitled *Norfolk Scenery* which he published 1810–1811.

38 *Beeston Hills – Sheringham in distance* Robert Dixon 23.3 × 30 cm watercolour (Castle Museum, Norwich)

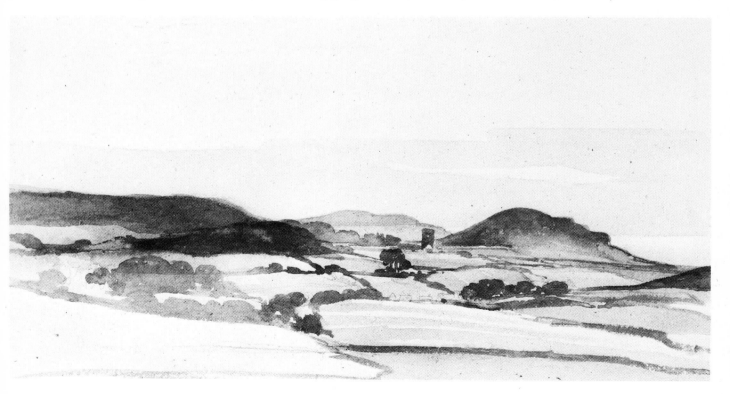

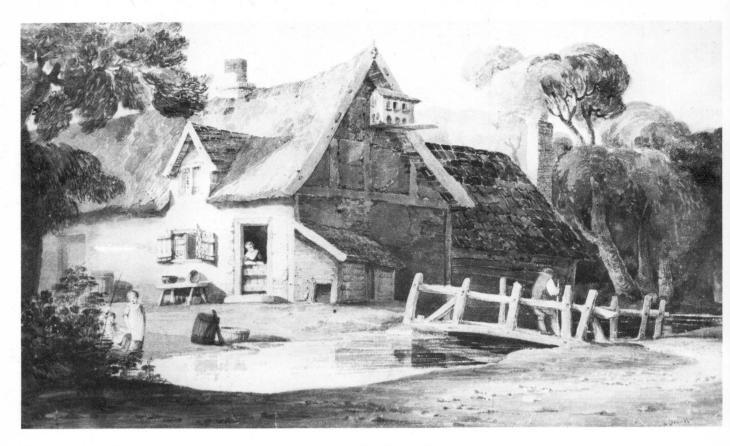

39 *Cottage scene* Robert Dixon 31.9×52.7 cm watercolour (Geoffrey Allen)

The Starks

James Stark (1794–1859) was turned to art by a school friendship with J. B. Crome, which led to his being articled to 'Old' Crome. In 1814 he went to London where he became a friend of William Collins, R.A., and in 1817 he entered the Royal Academy Schools. However, two years later his health made a return to Norwich necessary, and there he remained until 1830, when he returned to London for ten years. After this, he spent a further decade near Windsor, which gave him comparatively easy access to the New Forest which had become his favourite sketching ground. Lastly he returned once more to London, where he died. Despite his departures from Norwich, Stark must be considered as a Norwich artist, for he always practiced Crome's teachings and humbly sought only to reproduce nature. His son, Arthur James Stark, became a popular and successful cattle painter. Among Stark's pupils were Samuel David Colkett, Alfred Priest and Henry Jutsum.

40 *Windsor Castle* James Stark 44.1 × 58.8 cm oil on canvas (Castle Museum, Norwich)

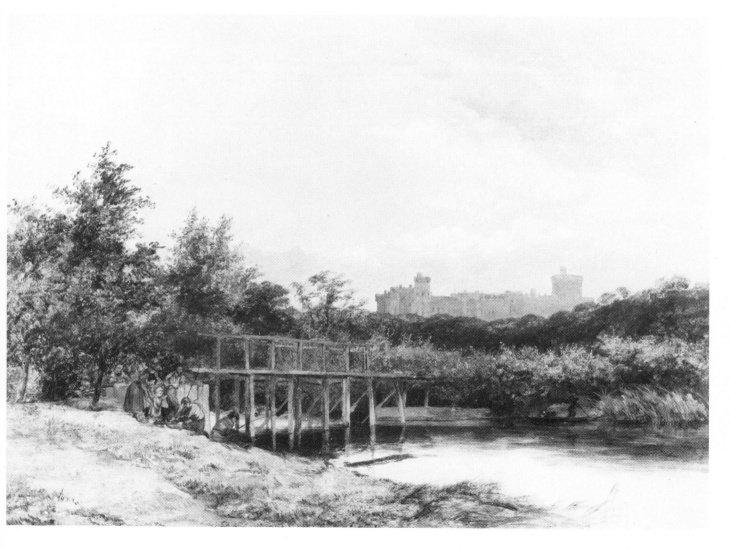

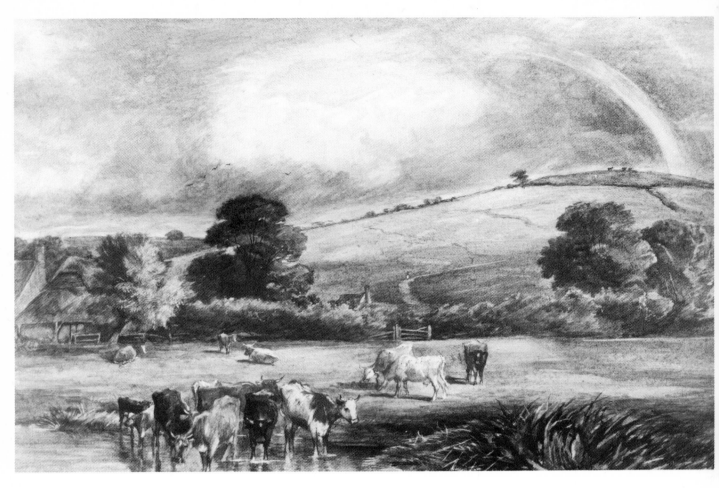

41 *A showery day* Arthur James Stark 32.6 × 49.9 cm watercolour (Castle Museum, Norwich)

J. B. Crome

John Berney Crome (1794–1842) was the eldest son of John Crome and began an early artistic career with exhibits at Norwich in 1806 and at the Royal Academy in 1811. In 1816, as the culmination of his education, he visited Paris with George Vincent and his future brother-in-law, Mr. Steel. On his return he helped his father with his pupils and by 1819 had become President of the Norwich Society, as well as being appointed to the largely honorific post of Landscape Painter to H.R.H. the Duke of Sussex. His style was largely based on that of his father, but he owed more to Cuyp, perhaps, than to 'Old' Crome's favourite Hobbema, and in his celebrated moonlight scenes he was greatly inspired by van der Neer. His attempts to reactivate the Society after its demise in 1825, and his efforts to set his own affairs on a sound financial basis, were alike unsuccessful, and, after being declared bankrupt in 1831, he retired to a drawing practice in Yarmouth for the last years of his life.

Two of his brothers, Frederick James and William Henry, and one sister, Emily, showed certain artistic talent, Frederick primarily as an etcher, and William Henry as a promising landscapist.

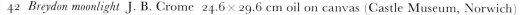

42 *Breydon moonlight* J. B. Crome 24.6 × 29.6 cm oil on canvas (Castle Museum, Norwich)

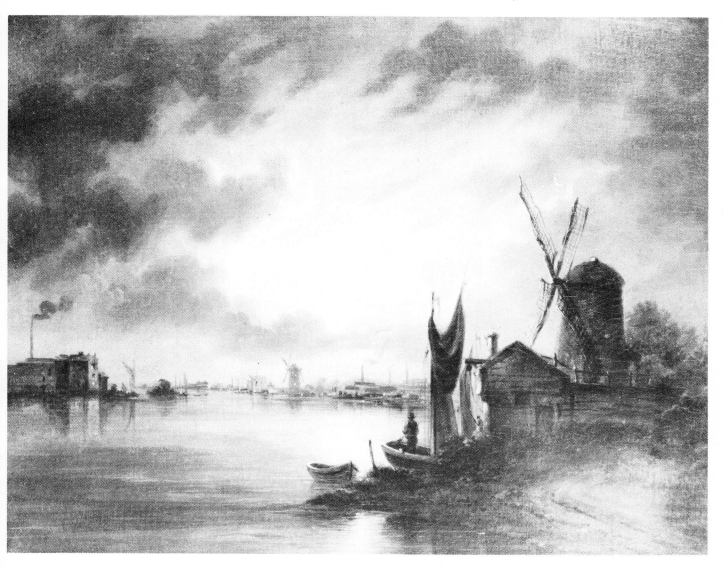

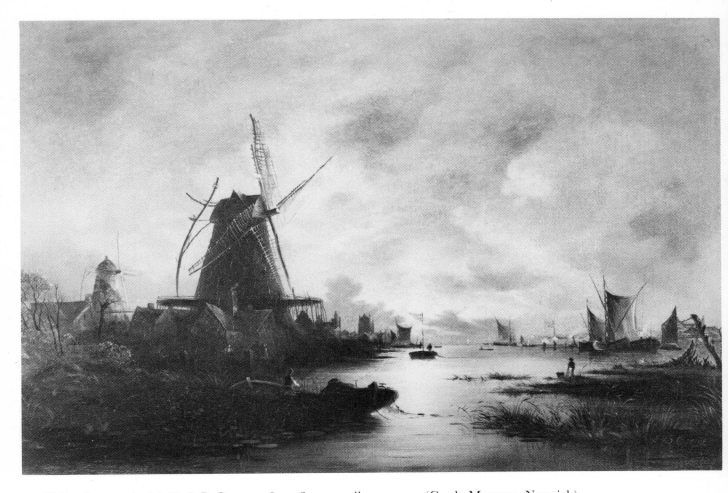

43 *Fishing boats on the Scheldt* J. B. Crome 58.1 × 61.9 cm oil on canvas (Castle Museum, Norwich)

George Vincent

George Vincent (1796–1831) was another artist who became a pupil of Crome through a boyhood friendship with J. B. Crome, with whom he went to Paris. He later went to London with James Stark, but by 1824 he had got into serious financial difficulties and spent the next two years as a prisoner for debt in the Fleet. He is presumed to have died – there is no record – with his great talent largely unrecognised, in 1831. Many of his pictures and watercolours were of Scottish subjects and thus, unless signed, may pass undetected.

44 *Trowse meadows near Norwich* George Vincent 71 × 105.9 cm oil on canvas (Castle Museum, Norwich)

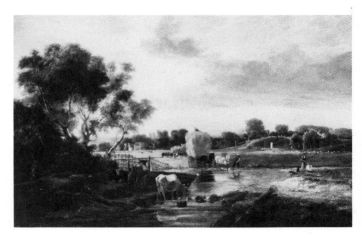

45 *Fish auction* George Vincent 61.25 × 89.4 cm oil on canvas (Castle Museum, Norwich)

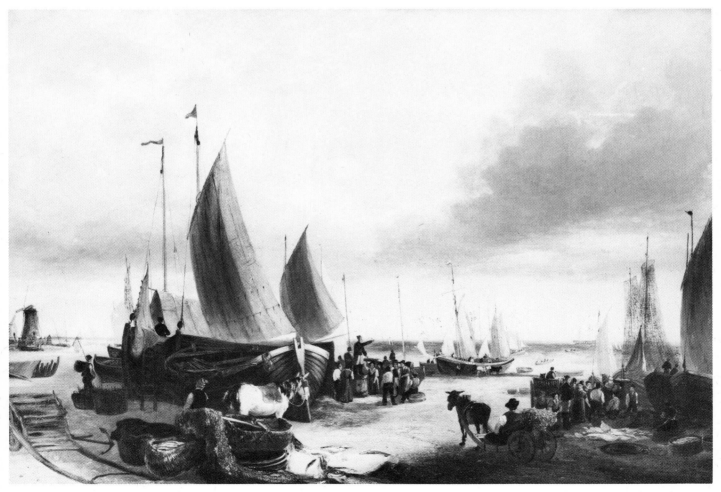

The Stannards

The Stannards were another prolific family of Norfolk artists, and the brothers Joseph (1797–1830) and Alfred (1806–1889) were among the strongest marine painters of the School. Joseph in particular, a former pupil of Robert Ladbrooke, shows a breadth of composition and a sense of atmosphere that is almost reminiscent of Cotman. Alfred's style is similar, with an added neatness and finish that is unusual in Norwich painting. His son Alfred George (1828–1885) followed the same path, while the women of the family concentrated on still life painting. The most notable of them were Mrs. Joseph Stannard (1803–1885), who was Emily Coppin, the daughter of Daniel, and Alfred's daughter, Eloise Harriet.

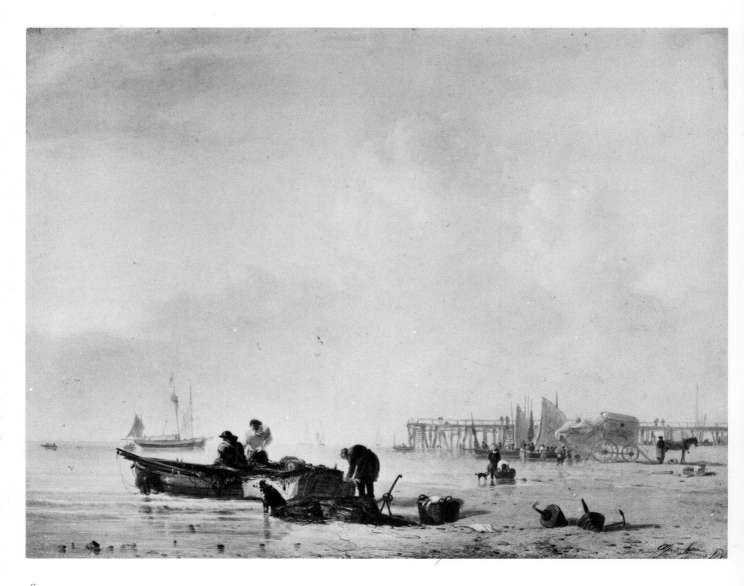

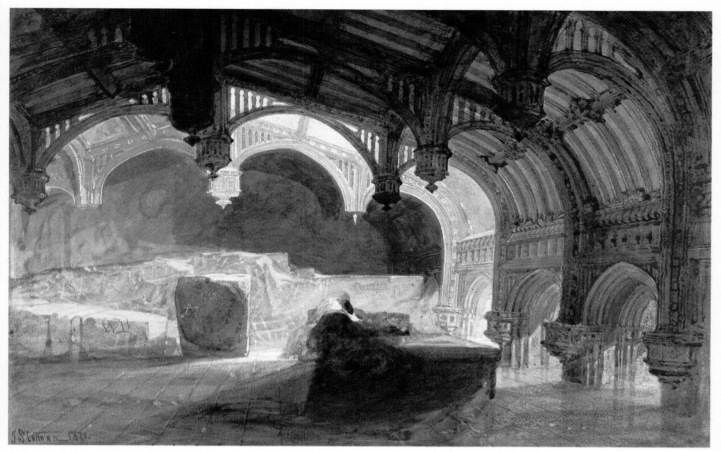

IV *Crosby Hall* John Sell Cotman 35 × 52 cm watercolour (Castle Museum, Norwich)

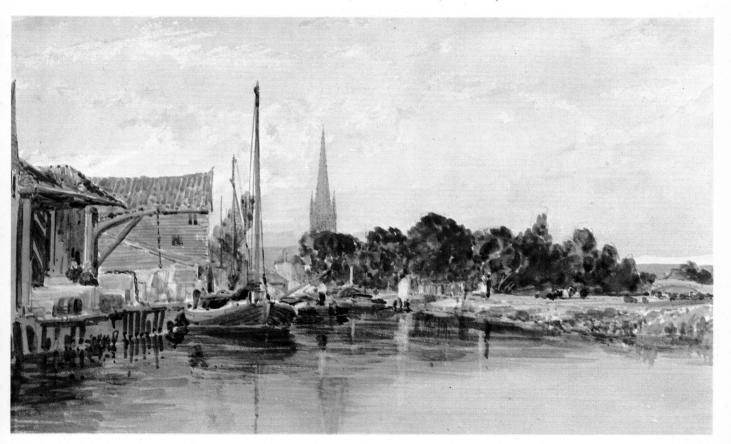

V *The river Wensum* Thomas Lound 21.6 × 30.4 cm watercolour (Castle Museum, Norwich)

VI *(overleaf)* *The second cataract of the Nile 1841* Rev. E. T. Daniell 48.2 × 69.9 cm watercolour (Castle Museum, Norwich)

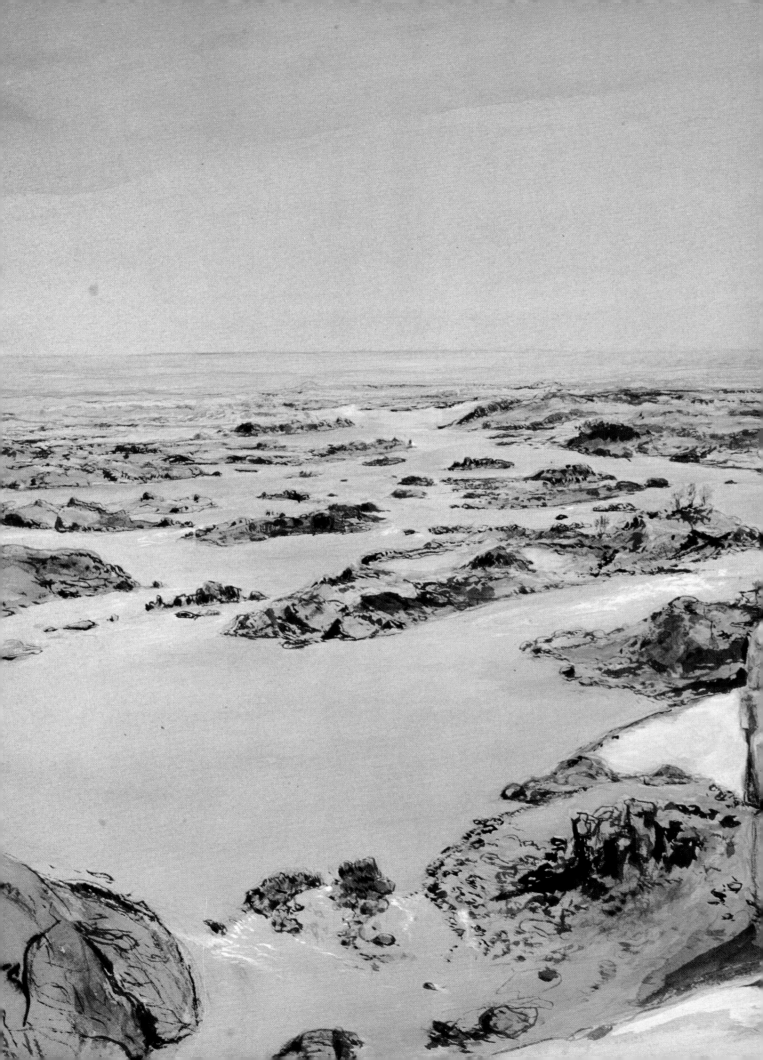

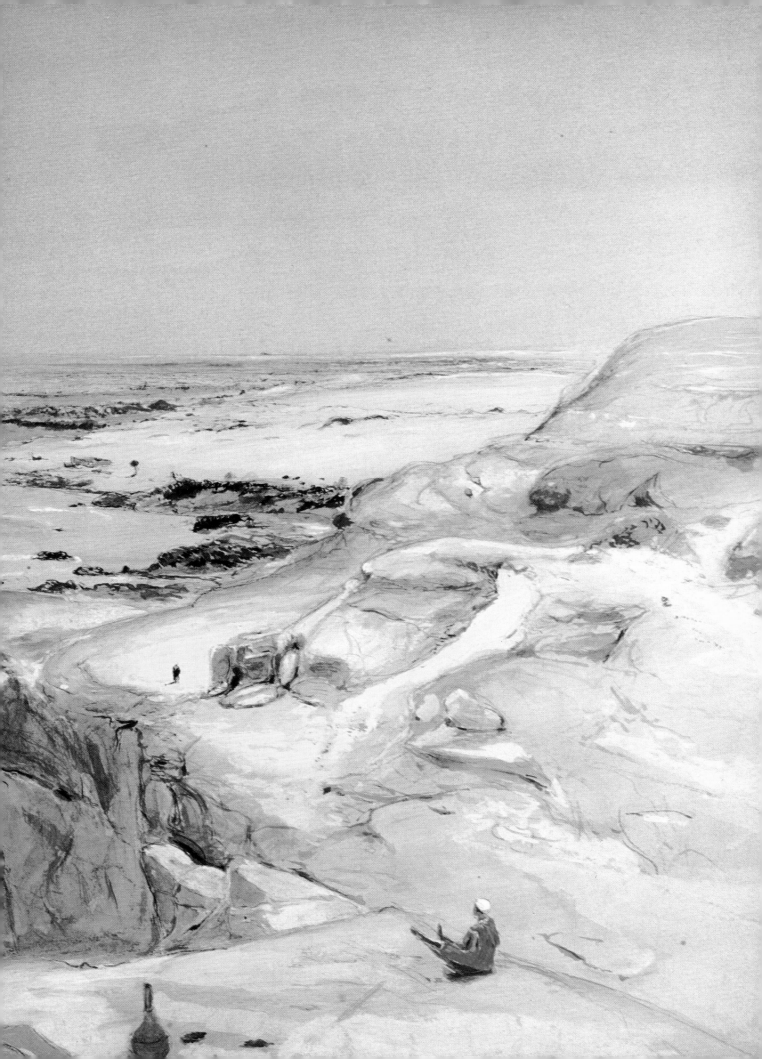

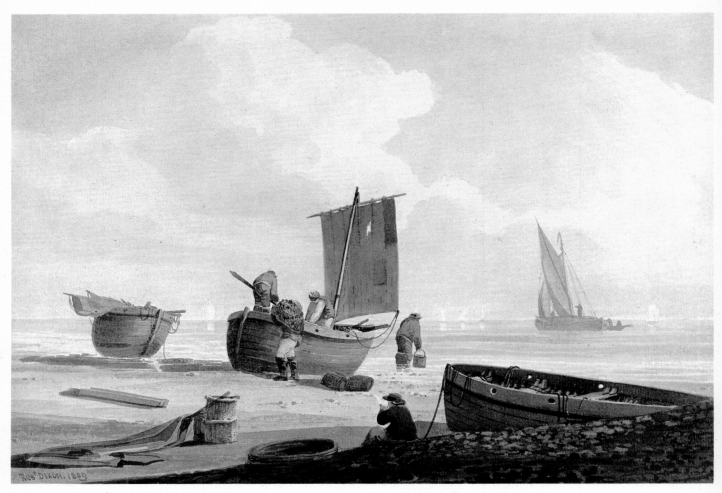

VII *On the East Coast 1809* Robert Dixon 30.3 × 43 cm watercolour (Castle Museum, Norwich)

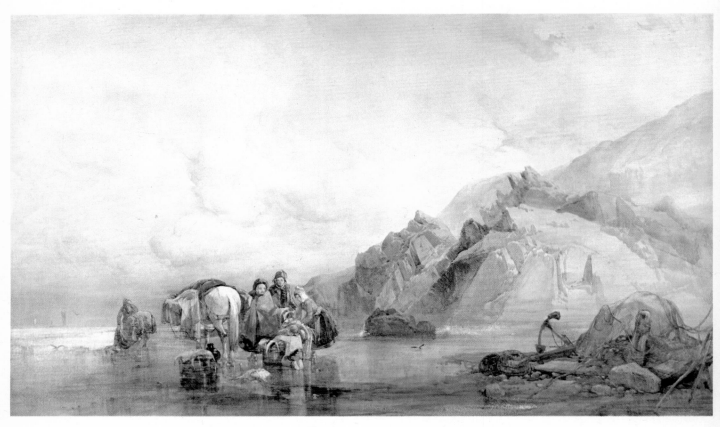

VIII *Beach scene with figures* Henry Bright 47.5 × 76 cm watercolour (Castle Museum, Norwich)

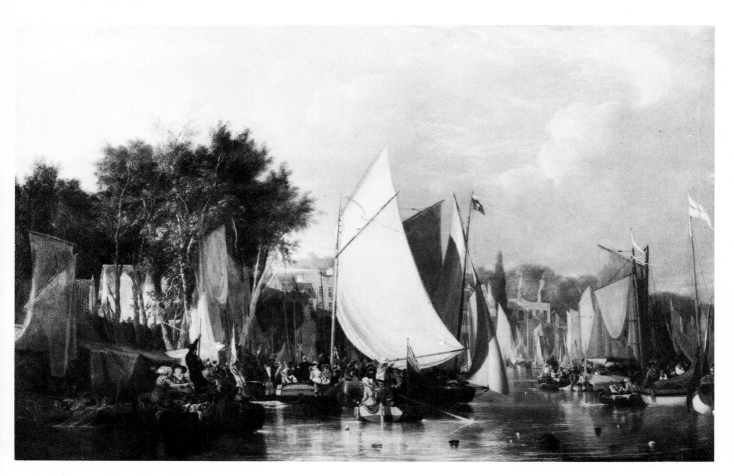

47 *Thorpe water frolic* Joseph Stannard 104.1 × 166.6 cm oil on canvas (Castle Museum, Norwich)

46 *Yarmouth jetty 1861* Alfred Stannard 30.6 × 39.2 cm oil (Castle Museum, Norwich)

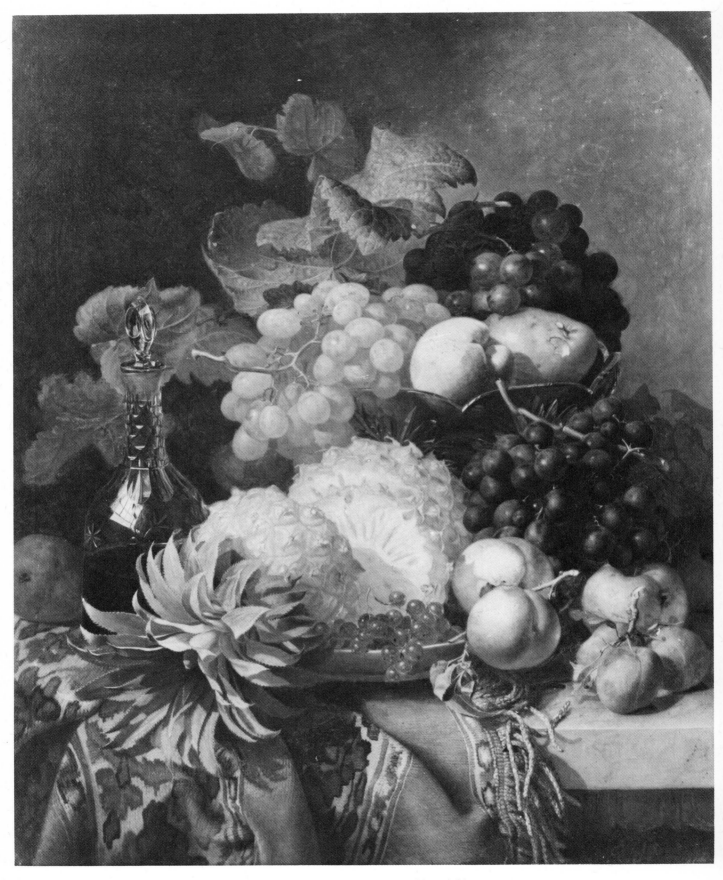

48 *Fruit* Eloise Harriet Stannard 66.8 × 55.1 cm oil (Castle Museum, Norwich)

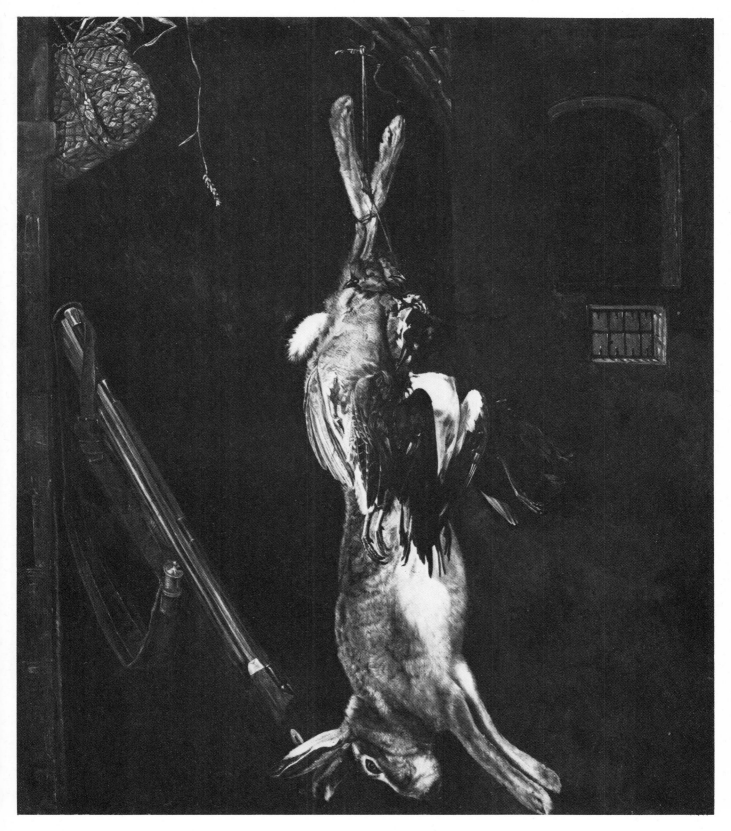

49 *Still life with a hare* Emily Stannard dimensions not known oil (Christie's)

Robert Leman

Robert Leman (1799–1863) was a pupil of Cotman, and at times he was very close in style to his friends Lound and Middleton. Little is known of him, except that like Lound he was an amateur, although of a very high degree of accomplishment.

50 *The shepherd on the heath* Robert Leman 17.2 × 25.1 cm watercolour (Castle Museum, Norwich)

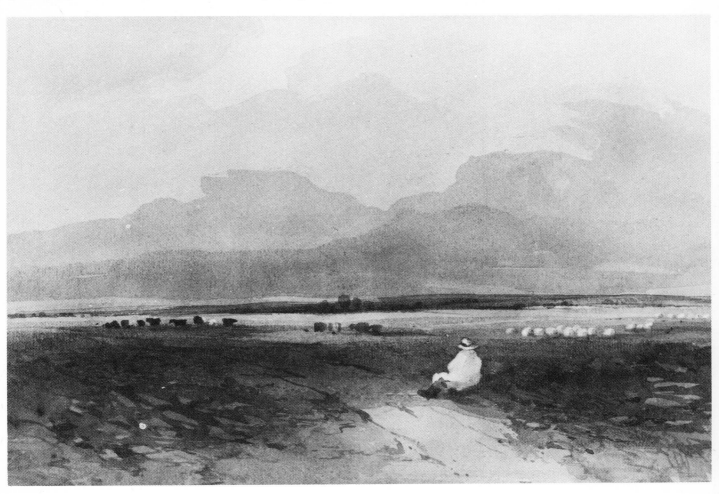

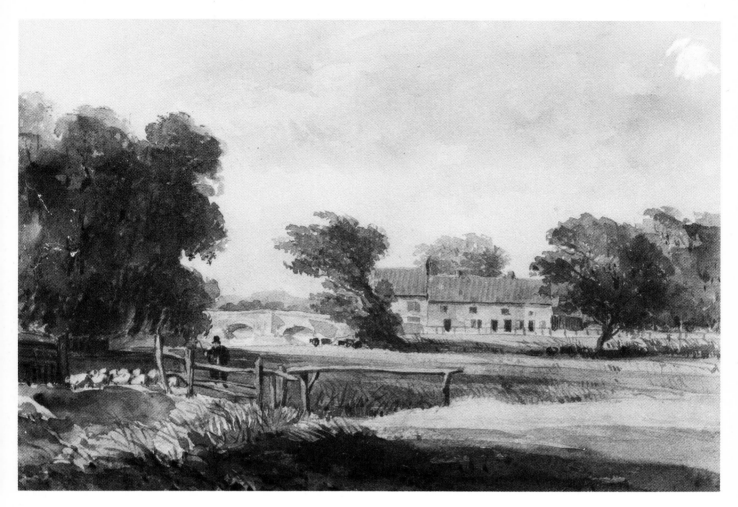

51 *At Trowse* Robert Leman 23.9×32.5 cm watercolour (Castle Museum, Norwich)

Thomas Lound

Thomas Lound (1802–1861), like Daniell, was an amateur and a man of substance, being a brewer. He was also a keen sailor, a photographer and a collector of pictures and drawings. He was taught drawing by Cotman and became a friend of the whole Cotman family, and his watercolour copies can be deceptively close to the master's. He was, in fact, chiefly a watercolourist, although his oils are not to be despised, showing considerable technique, if somewhat clumsy, in the handling of trees. In his watercolours, he learnt from Cox and Thirtle as well as from Cotman, and he shows much strength, but again a certain clumsiness of detail.

52 *The harvest field* Thomas Lound 18.4 × 26.5 cm watercolour (Castle Museum, Norwich)

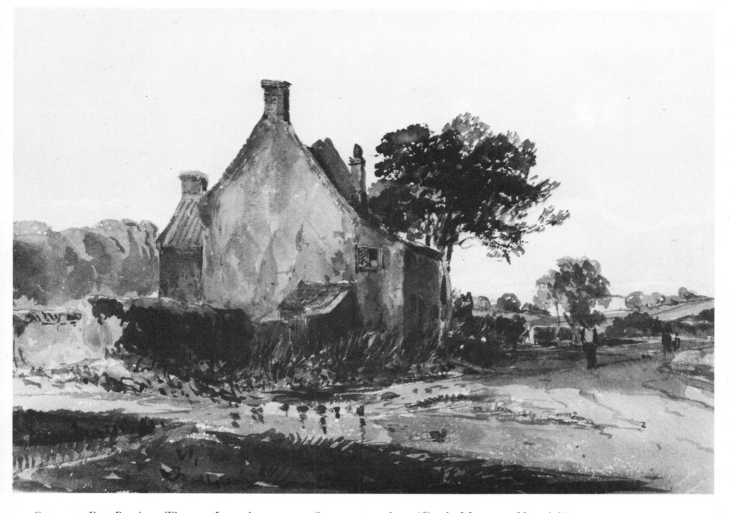

53 *Cottage at East Barsham* Thomas Lound 22.5 × 31.6 cm watercolour (Castle Museum, Norwich)

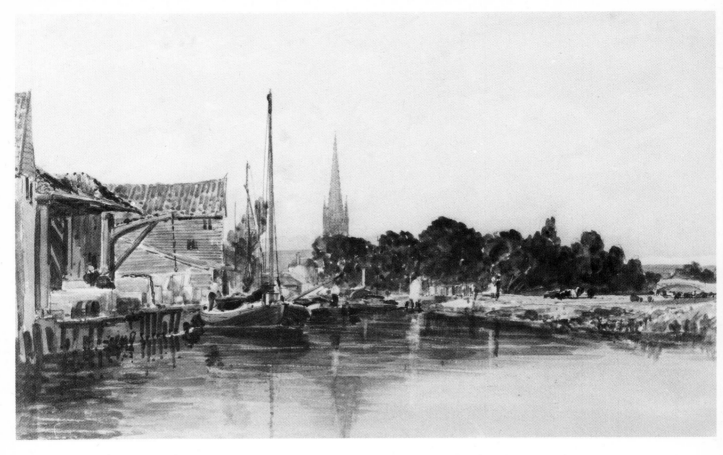

54 *Norwich cathedral from the riverside* Thomas Lound 20.8 × 29.4 cm watercolour (Castle Museum, Norwich)

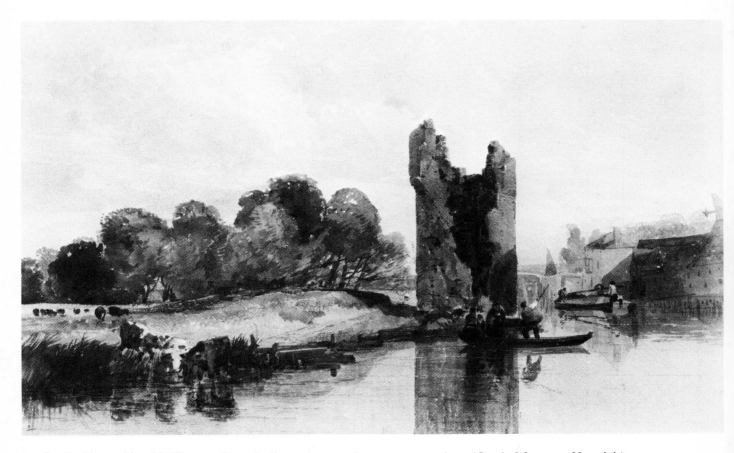

55 *Devil's Tower, Norwich* Thomas Lound dimensions not known watercolour (Castle Museum, Norwich)

The Reverend Edward Thomas Daniell

The Reverend Edward Thomas Daniell (1804–1842) was the son of a former Attorney-General of Dominica. Although he was born in London, he was brought up at the family's Norfolk home and attended the grammar school where he was taught drawing by Crome. He went up to Balliol in 1823, but showed a strong interest in artistic matters during the vacations, visiting Linnell in London and frequenting Joseph Stannard's Norwich studio. In 1831 he was ordained and spent two years in a Norfolk curacy, but then moved to London and fully entered the artistic life of the capital. He was so impressed by Roberts' Egyptian drawings that in 1840 he joined the Lycian expedition and died of fever in Asia Minor. He was a master of etching and dry point, and his watercolours have been well described as 'the perfection of free sketching'.

56 *Teignmouth* E. T. Daniell dimensions not known watercolour (Castle Museum, Norwich)

OVERLEAF

57 *Interior of convent, Mount Sinai, June 19 and 21 1841* E. T. Daniell 31.4 × 47.2 cm watercolour (Castle Museum, Norwich)

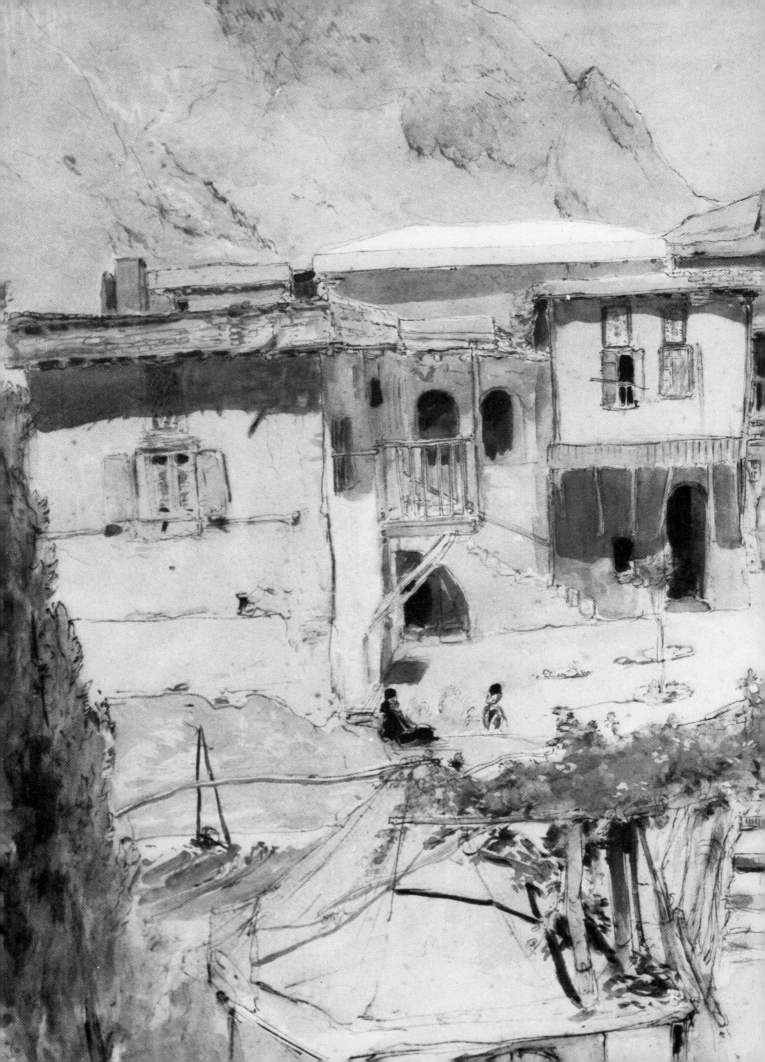

The Cotmans

Miles Edmund Cotman (1810–1858) continued in London after the death of his father, producing etchings, both of his own composition and after John Sell. He had always lived and worked under his father's shadow and continued to do so, but despite a 'hard dry manner' of painting, he was by no means an incompetent artist. He spent the last two years of his life at the Norfolk house of his brother John Joseph (1814–1878), the one child who escaped, at least partially, from the smothering genius of John Sell Cotman. He took over the family drawing practice in Norfolk, but was hampered by lack of self-discipline and an ample measure of his father's melancholia, bordering at times on madness. Unlike Miles Edmund, who made marine oil painting his speciality, John Joseph is chiefly known for his watercolours, which, while they show much of the hotness of his father's manner, sometimes contain echoes of the poetry of Samuel Palmer as well.

58 *Wooded landscape* Miles Edmund Cotman 72.3 × 115.2 cm oil (Castle Museum, Norwich)

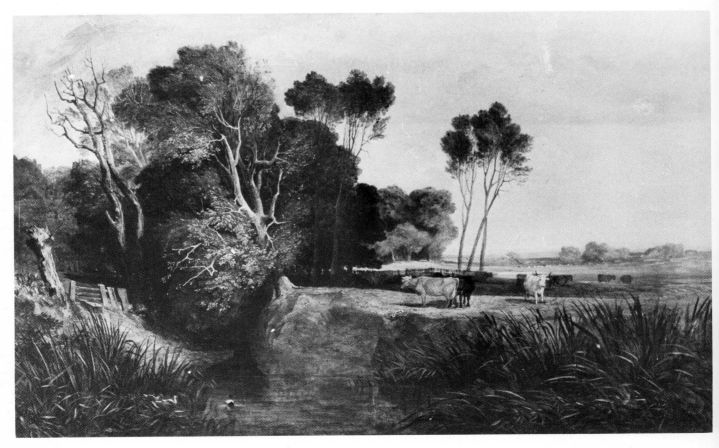

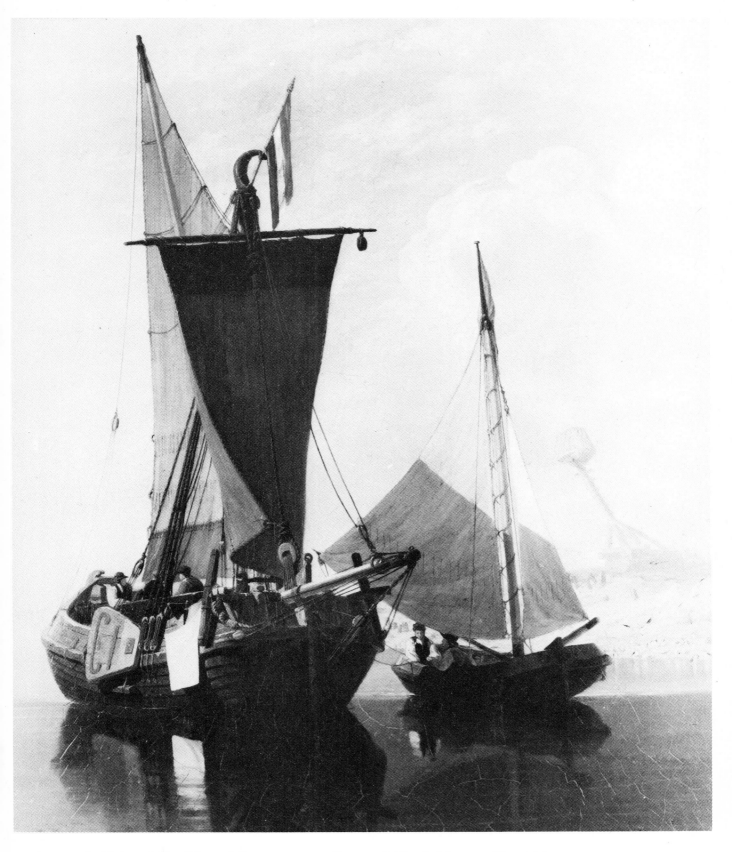

59 *Boats on the Medway* Miles Edmund Cotman 53.3 × 48.4 cm oil (Castle Museum, Norwich)

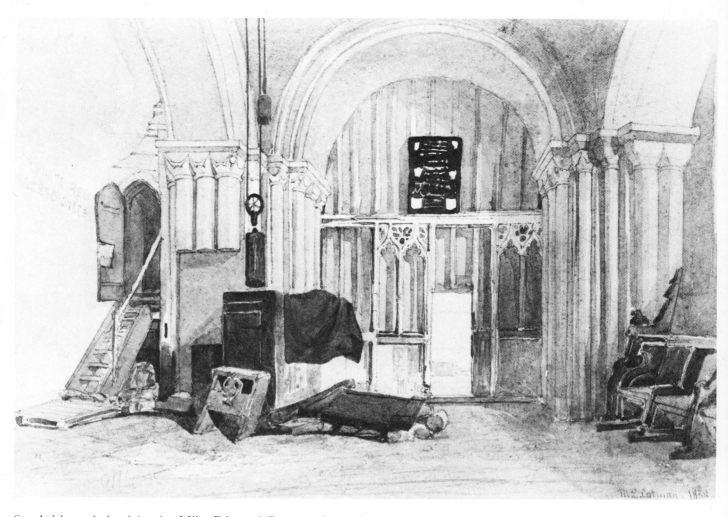

60 *Attleborough church interior* Miles Edmund Cotman dimensions not known watercolour (Castle Museum, Norwich)

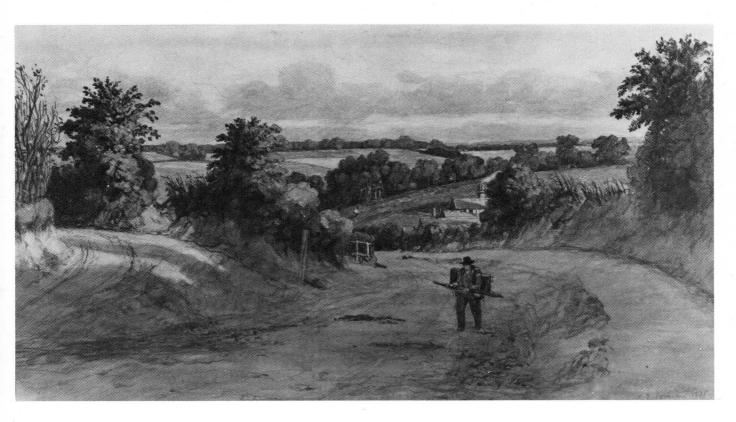

61 *A bagman in a country lane August 1875* John Joseph Cotman 29.2 × 22.9 cm pencil and watercolour (private collection)

62 *A river landscape* John Joseph Cotman 35.3 × 66.4 cm watercolour (private collection)

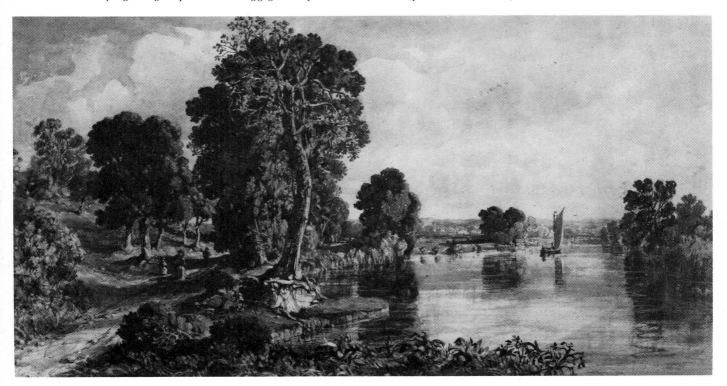

Henry Bright

Henry Bright (1810–1873) was in fact born in Suffolk and returned there to die, having spent at least twenty years of his working life in London. He was trained as a pharmacist, probably under family pressure, but soon turned to art, taking lessons from Alfred Stannard and probably J. B. Crome and J. S. Cotman. In 1836 he moved to London where he was well thought of by other artists and established himself as a highly fashionable drawing master. He travelled widely on the continent and throughout Britain. He was primarily a watercolourist and worked in a variety of styles, being unafraid of experimenting. His most common works are drawings done in a wild mixture of pastel, charcoal, water and body-colour on tinted paper, and with these in mind one must think the artist well named. However he also produced very sensitive drawings, as well as pure watercolours and a number of striking oil paintings.

63 *Old barn, Kent* Henry Bright 33.1 × 49 cm watercolour (Castle Museum, Norwich)

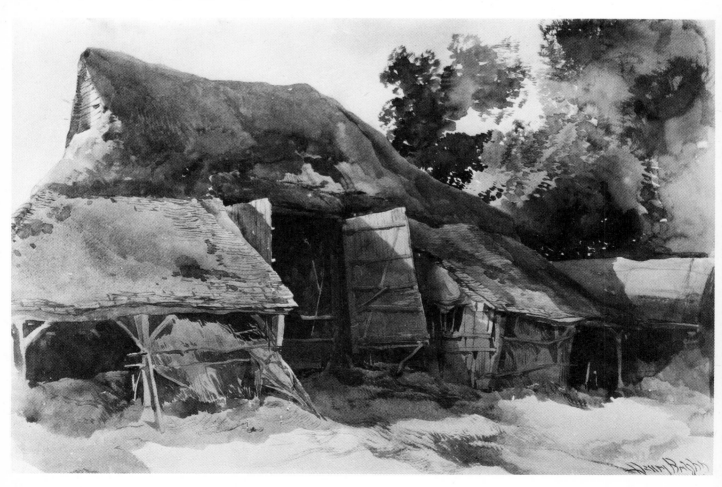

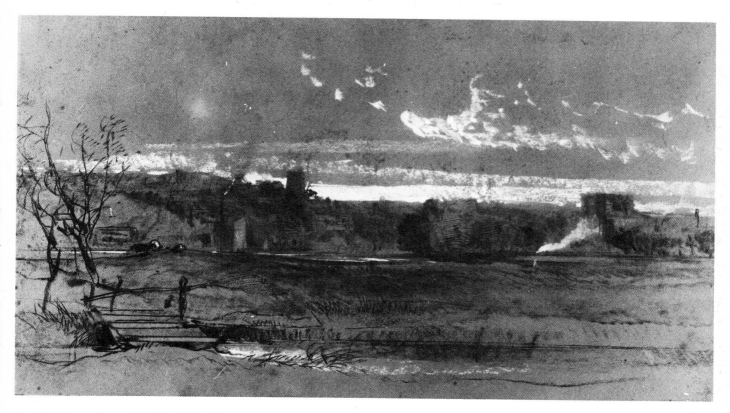

64 *Thorpe meadows with Norwich in the distance* Henry Bright 28.4 × 45.8 cm chalk on buff paper (Castle Museum, Norwich)

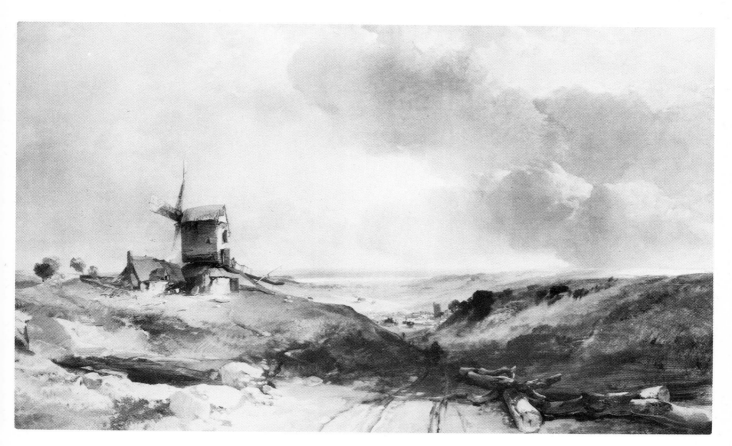

65 *Windmill at Sheringham* Henry Bright 77.8 × 128 cm oil (Castle Museum, Norwich)

John Middleton

John Middleton (1827–1856) was taught by J. B. Ladbrooke, Joseph Stannard and Henry Bright, and also learnt much from his friendship with Lound. He spent two years (1847–48) in London, but otherwise based himself in Norwich, where he died of consumption, after making one or two short trips to the coast and to Scotland. He was a painstaking and highly attractive artist, his water-colours in particular having retained their freshness and charm.

66 *Landscape with pollards* John Middleton 47.8 × 57.6 cm oil on canvas (Castle Museum, Norwich)

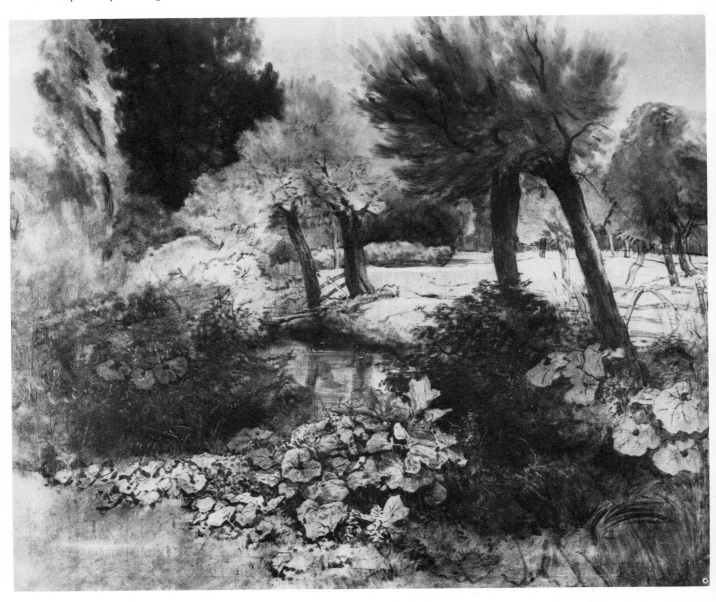

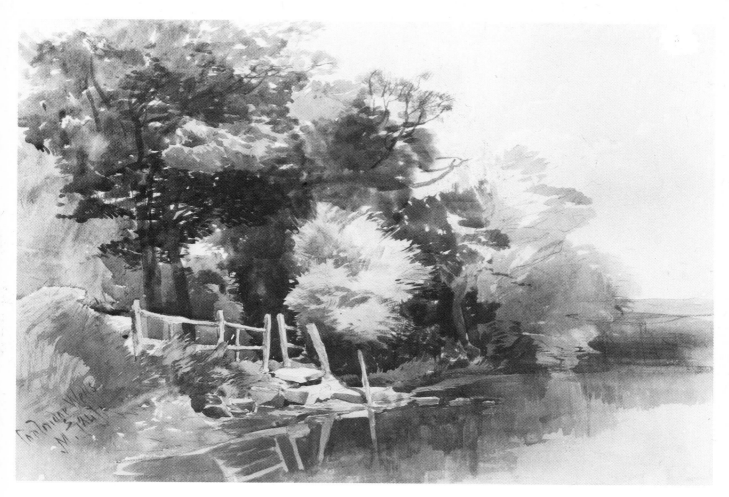

67　*Tunbridge Wells, 1847*　John Middleton　31.9 × 40.9 cm watercolour (Castle Museum, Norwich)

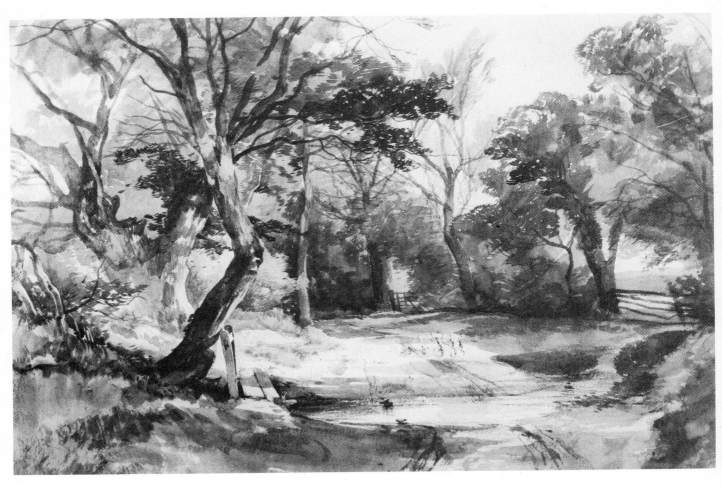

68 *Lane scene* John Middleton 31.2 × 45.3 cm watercolour (Castle Museum, Norwich)

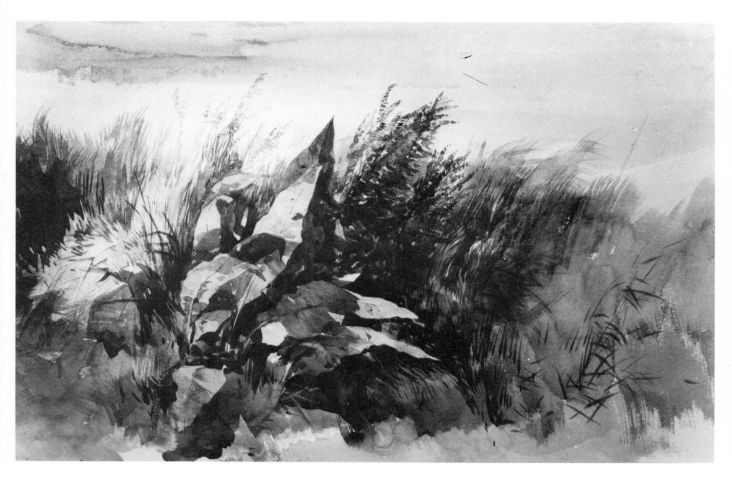

69 *Dock leaves* John Middleton 21.4 × 29 cm watercolour (Castle Museum, Norwich)

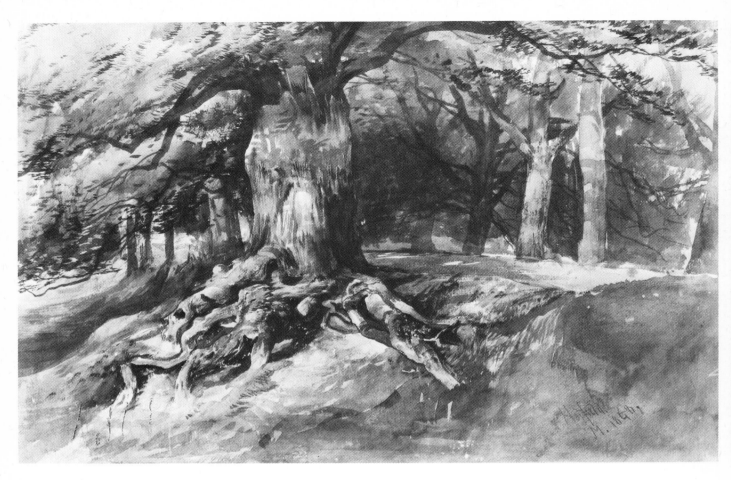

70 *At Hatfield* John Middleton 81.9 × 40.9 cm watercolour (Castle Museum, Norwich)

Members of the Norwich Society of Artists

	Period of Exhibitions		*Period of Exhibitions*
Barnes, Philip	1808–12	Fox, Charles	1807–28
Bartell, Edmund	1808–25	Freeman, Jeremiah	1805–17
Barwell, John	1813–33	Freeman, William Barnes	1805–17
Beechey, Sir William, R.A.	1825–31	Gooch, J.	1812–28
Bell, Edward	1805–30	Gordon, Rev. William	1805–17
Blake, T. jun.	1806–13	Harwin, W.	1805–6
Bowles, Henry	1807–8	Haydon, Benjamin Robert	1824
Britton, John, F.S.A.	1816–29	Higham, J. W.	1819–31
Browne, Arthur	1805–33	Hodgson, Charles	1805–25
Browne, Robert	1807–12	Hodgson, David	1813–33
Burnet, John	1822–28	Ladbrooke, John Berney	1816–33
Cattermole, George	1829–33	Ladbrooke, Robert	1805–33
Churchyard, Thomas	1829	Leeds, W. C.	1805–8
Clint, George, A.R.A.	1823–33	Leeds, W. C. jun.	1805–7
Clover, Joseph	1813–32	Love, Horace Beevor	1819–33
Cockburn, Major-General James Pattison	1809	Mackenzie, Frederick	1811–32
Collins, William, R.A.	1816–17	Osborne, Charles	1820–28
Cooke, George	1828–9	Percy, J.	1805–6
Cooper, Edwin W.	1806–32	Reinagle, Ramsay Richard, R.A.	1815–22
Coppin, Daniel	1807–16	Roberts, William	1825–32
Cotman, John Sell	1807–33	Sharp, Michael William	1813–21
Cotman, Miles Edmund	1823–33	Shee, Sir Martin Archer, R.A.	1817–20
Crome, Emily	1816–33	Sillett, James	1806–33
Crome, Frederick	1808–21	Spratt, William	1810–15
Crome, John	1805–29	Stannard, Mrs. Joseph	1816–32
Crome, John Berney	1806–33	Stark, James	1809–32
Crome, William Henry	1822–33	Stevens, Francis	1809
Crotch, M. B.	1805–17	Stone, Francis	1805–16
Curtis, John	1810–20	Stone, Francis Henry	1815–25
Davis, J. P.	1816–32	Thirtle, John	1805–30
Davison, William	1824–28	Thorold, W.	1823–24
Dixon, Robert	1805–10	Varley, John	1809–31
Donthorne, William John	1815–30	Vincent, George	1811–31
Drake, F.	1829–30	Wilkins, William	1818–28
Earl, Ralph Eleaser Whiteside	1810–15		